22, 502, 1008

902576

ASSESSMAND COLLEGE OF FURTHER EDUCATION

BRAMSTON CRESCENT

This book is due for return on or before the last date shown below.

	CVA 95 W
52x Jal 1825	

Don Gresswell Ltd., London, N.21 Cat. No. 1208

DG 02242/71

HEREWARD COLLEGE OF FURTHER EDUCATION

BRAMSTON CRESCENT

COVENTRY

CV4 95W

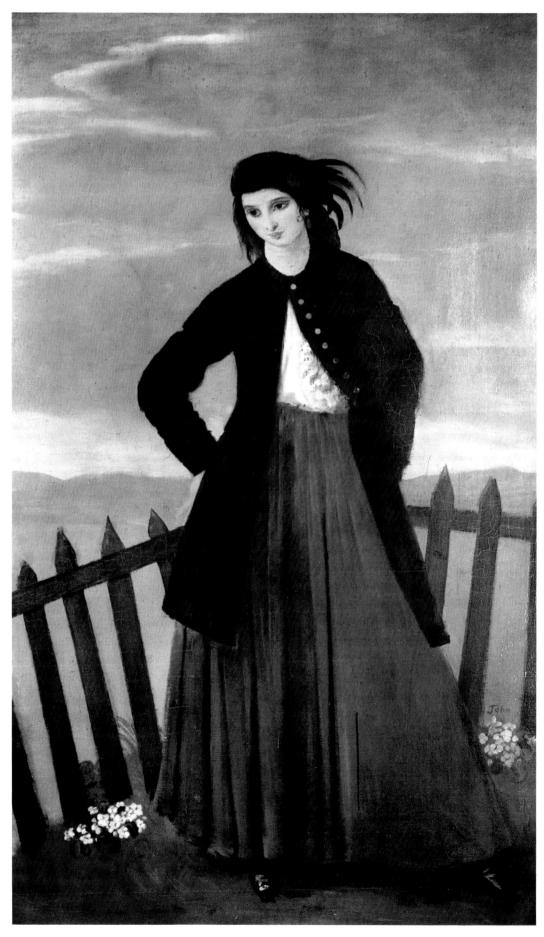

dorelia standing before a fence, c. 1903–4 (Miss Jemima Pitman) (see p. 45)

THE ART OF MAUGUSTUS JOHN

Malcolm Easton
and
Michael Holroyd

Secker & Warburg

First published in England 1974 by Martin Secker & Warburg Limited 14 Carlisle Street, London W1V 6NN

Text and Selection of Works by Augustus John Copyright © Michael Holroyd and Malcolm Fyfe Easton 1974

SBN: 436 14071 3

Printed in Great Britain by Westerham Press Limited, Westerham, Kent

S Contents

List of Plates vi
Acknowledgements viii
The Art of Augustus John 1
Chronology 35
Plates 43
Appendixes 212
List of Owners 216

es List of Plates

_		PAGI
Frontispiece	DORELIA STANDING BEFORE A FENCE, c. 1903–4 Miss Jemima Pitman	
1	AN OLD LADY, 1899 Tate Gallery, London	47
2	IDA, c. 1901–2 Mr and Mrs John Gardner	49
3	IDA PREGNANT, ? 1901 National Museum of Wales, Cardiff	51
4	SIGNORINA ESTELLA CERUTTI, 1902 City Art Gallery, Manchester	53
5	ARDOR, c. 1903 City Art Gallery, Manchester	55
6	GYPSY ENCAMPMENT, 1905 Private Collection	57
7	FRENCH FISHER-BOY, 1907 Mr and Mrs Stephen Tumim	59
8	W. B. YEATS, 1907 City Art Gallery, Manchester	61
9	THE SMILING WOMAN, 1909 Tate Gallery, London	63
10	NEAR THE VILLA STE ANNE, 1910 Private Collection	65
11	DORELIA WITH THREE CHILDREN, 1910 Mr Peter Harris	67
12	PYRAMUS, c. 1910 Private Collection	69
13 14	LLYN TREWERYN, 1911 Tate Gallery, London	71
15	ROMILLY, ROBIN AND EDWIN, 1911 Lady Kleinwort	73
16	THE MUMPER'S CHILD, c. 1912 Mr Peter Harris	75
17	LYRIC FANTASY, 1911–15 Tate Gallery, London GALWAY SUBJECT, 1916 Gwen Lady Melchett	77
18	THE MARCHESA CASATI, 1919 Art Gallery of Ontario, Toronto	79
19	LADY OTTOLINE MORRELL, c. 1919 Mrs Julian Vinogradoff	81
20	MADAME SUGGIA, 1923 Tate Gallery, London	83 85
21	PEONIES IN A JUG, after 1925 Mrs Thelma Cazalet-Keir	87
22	THE LATE LADY ADEANE, 1929 Sir Robert Adeane	89
23	HEAD OF A JAMAICAN GIRL, probably 1937 Mr Richard Burrows	91
24	MIXED FLOWERS IN A GLASS JAR, c. 1938 Private Collection	93
25	STUDIES OF A MALE NUDE WITH A STAFF, ϵ . 1897 Gwen Lady Melchett	95
26	IDA NETTLESHIP, URSULA TYRWHITT AND GWEN JOHN, c. 1897	33
	Private Collection	97
27	BENJAMIN EVANS, ? 1897–8 Messrs P. and D. Colnaghi	99
28	MOSES AND THE BRAZEN SERPENT, 1898 The Slade School of Fine Art,	
	University College, London	101
29	TETE FAROUCHE (PORTRAIT OF THE ARTIST), ? 1899–1900	
	National Museum of Wales, Cardiff	103
30	MERIKLI, 1901–2 City Art Gallery, Manchester	105
31	JOHN SAMPSON, ? 1903 Present owner untraced	107
32	WYNDHAM LEWIS, c. 1903 Messrs Thomas Agnew and Sons	109
33	studies of young children, c. 1904 Private Collection	111
34	CARAVAN AT DUSK, 1905 Mr Richard Driver	113
35	THE WOMAN IN THE TENT, 1905 Mr Peter Harris	115
36	WYNDHAM LEWIS, c. 1905 Mr Anthony Speelman	117
37	ALICK SCHEPELER, 1906 Fitzwilliam Museum, Cambridge	119
38	DAVID IN A LARGE HAT, ϵ . 1906 Private Collection	121
39	PYRAMUS ASLEEP, c. 1906 John Estate	123

		PAGE
40	ALICK SCHEPELER, 1906–7	
	Print Department, Public Library, Boston, Massachusetts	125
41	DAVID AND DORELIA IN NORMANDY, ? 1907	
10	Fitzwilliam Museum, Cambridge	127
42	PEASANT WOMAN WITH BABY AND SMALL BOY, c. 1907	1.00
4.0	Present owner untraced	129
43	DORELIA STANDING, c. 1907–8 Tate Gallery, London	131
44	studies of dorelia, c. 1907–8 Mrs Thelma Cazalet-Keir	133
45	THE BLUE SHAWL (DORELIA), c. 1907–8 Fitzwilliam Museum, Cambridge	135
46	CASPAR, c. 1907–8 Mr Brinsley Ford	137
47	LADY OTTOLINE MORRELL, c. 1908 Mr and Mrs Benjamin Sonnenberg	139
48	sir william Nicholson, 1909 Fitzwilliam Museum, Cambridge	141
49	CHALONER DOWDALL AS LORD MAYOR OF LIVERPOOL, 1909	1.40
E ()	National Gallery of Victoria, Melbourne, Australia	143
50	CASPAR, c. 1909 Mr Peter Harris	145
51	EDWIN AND ROMILLY, c. 1910 Private Collection	147
52 52	DR KUNO MEYER, 1911 National Gallery of Ireland, Dublin	149
53	THE RED FEATHER, c. 1911 Private Collection	151
54	THE BLUE POOL, DORELIA STANDING, c. 1911	150
5.5	Mrs Thelma Cazalet-Keir	153
55 = C	THE MUMPERS, 1912 Detroit Institute of Arts	155
56 57	GEORGE BERNARD SHAW, 1915 Fitzwilliam Museum, Cambridge	157
57	CARTOON FOR GALWAY, 1916 Tate Gallery, London	159
58	ARTHUR SYMONS, 1917 Mr Peter A. Salm	161
59 60	FRATERNITY, 1918 Imperial War Museum, London	163
60	CANADIANS AT LIEVIN CASTLE, 1918 Requestrook Art College Fredericton N.P.	1.05
61	Beaverbrook Art Gallery, Fredericton, N.B.	165
61 62	RONALD FIRBANK, c. 1917–19 Present owner untraced	167
63	T. E. LAWRENCE, 1919 National Portrait Gallery, London W. H. DAVIES, c. 1920 National Museum of Wales, Cardiff	169
64	IN MEMORIAM AMEDEO MODIGLIANI, c. 1920 Executors of A. C. J. Wall	171
65	THE SPANISH GITANA, before 1921 Miss Amaryllis Fleming	173 175
66	THOMAS HARDY, 1923 Fitzwilliam Museum, Cambridge	173
	VISCOUNT D'ABERNON, 1927–31 Tate Gallery, London	179
	VISCOUNT D'ABERNON (photograph) John Estate	181
68	THE ARTIST'S DAUGHTER, POPPET, c. 1927–8	101
00	National Gallery of Victoria, Melbourne, Australia	183
69	THE LITTLE RAILWAY, MARTIGUES, 1928 Tate Gallery, London	185
70	JAMES JOYCE, 1930 Present owner untraced	187
71	JAMES JOYCE, 1930 Mr Cass Canfield	189
72	Joseph номе, 1932 Tate Gallery, London	191
73	DYLAN THOMAS, c. 1936 National Museum of Wales, Cardiff	193
74	TWO JAMAICAN GIRLS, 1937 Walker Art Gallery, Liverpool	195
75	ROCKY LANDSCAPE, ST-REMY, c. 1938 Mrs R. M. Hughes	197
76	BRINSLEY FORD, 1941 Mr Brinsley Ford	199
77	SIR MATTHEW SMITH, 1944 Tate Gallery, London	201
78	CYRIL CONNOLLY, 1945 Private Collection	201
79	SELF-PORTRAIT, c. 1950 Mr William A. Coolidge	205
80	JOHN COWPER POWYS, 1955 Present owner untraced	207
81	DORELIA, before 1959 Miss Amaryllis Fleming	209
82	STUDY FOR THE CENTRAL PANEL OF A TRIPTYCH,	403
	'LES SAINTES-MARIES', 1960 Sir Charles Wheeler	211
	, Too on charles in the contract of the c	411

S List of Figures in the Text **S**

		PAGE
i	THE PROMENADE, c. 1900 John Estate	3
	CHURCHYARD SCENE, c. 1901 Miss Amaryllis Fleming	5
	DESESPERANCE D'AMOUR, c. 1902 John Estate	7
iv	SPECTATORS IN A PICTURE-GALLERY (?), c. 1912 John Estate	9
V	THE BRAGGING SOLDIER, 1915 Miss Amaryllis Fleming	14
	A CLASSICAL SUBJECT, ? 1915 John Estate	19
	ENTRANCE TO A BROTHEL, 1917 John Estate	25
7111	PLAISIBS ET MISERES DES COURTISANES, ? c. 1920 John Estate	29

Acknowledgements &

We are indebted above all to the artist's family, particularly to Admiral of the Fleet Sir Caspar John and Mr Romilly John. We have also received invaluable assistance from Mme Poppet Pol, Mrs Vivien White, Mr Edwin John, and the late David John.

While respecting the wishes of others to remain anonymous, we thank the following owners for permission to reproduce their property: Sir Robert Adeane; Mr Richard Burrows; Mr Cass Canfield; Mrs Thelma Cazalet-Keir; Mr Richard Driver; Miss Amaryllis Fleming; Mr Brinsley Ford; Mr and Mrs John Gardner; Mr Peter Harris; Mrs R. M. Hughes; Lady Kleinwort; Gwen Lady Melchett; Miss Jemima Pitman; Mr Peter A. Salm; Mr and Mrs Benjamin Sonnenberg; Mr Anthony Speelman; Mr and Mrs Stephen Tumin; Mrs Julian Vinogradoff; Sir Charles Wheeler. We gratefully acknowledge leave to reproduce works by Augustus John in the National Portrait Gallery; the Tate Gallery; the Imperial War Museum; the National Gallery of Ireland; the National Museum of Wales; the National Gallery of Victoria, Melbourne; the Art Gallery of Ontario; the Beaverbrook Art Gallery, New Brunswick; Boston Public Library (Department of Prints); the Detroit Institute of Arts; the Fitzwilliam Museum, Cambridge; University College, London; the City Art Gallery, Manchester; the Walker Art Gallery, Liverpool. Messrs Thomas Agnew and Sons and P. and D. Colnaghi very kindly supplied us with photographs of prints in their possession.

We have been fortunate in the help given us at various stages and in various ways by Miss Dobi Adeane, Miss Miriam J. Benkovitz, Mr Rollo Charles, Mr Joseph Darracott, Mr Arthur Driver, Dr M. Roy Fisher, Mr Geoffrey Green, Mr Clifford Hall, Mr Max Harari, Mrs Sarah Jacobs, Mr John Lumley and Mr Godfrey Pilkington; and privileged to consult the archive of Augustus John photographs in the National Museum of Wales, the Witt Library at the Courtauld Institute, and the collection of exhibition-catalogues belonging to the Library of the Victoria and Albert Museum.

For newly-commissioned photographs we have been largely dependent upon the skill of Miss Eileen Tweedy.

The Art of Augustus John

3 1 **3**

O VER-EXPOSURE OF the creator is peculiarly unfortunate in the visual arts, where one expects to have eyes only for the thing created. And it was Augustus John's whim to transform himself into the kind of 'picturesque man' against whom Nietzsche has issued a special warning. He hit the headlines with unwearying zest and lived long enough to make his final truculent bow on television. What did he care for the critics and their accumulating stocks of gelignite? In the end, and long before he died in 1961, aged eighty-three, his great reputation had been blown sky-high.

The fragments of that reputation, however, as at last they drift down to earth again, seem to the authors of the present essay to form a new, exciting pattern. Like the man himself,¹ the artist demands reappraisal. When a figure of importance in the history of our time is currently underrated both by the State's appointed guardians of culture and by Royal Academicians at Burlington House, something must be wrong somewhere. Without attempting a 'rescue operation' (John's own contemptuous phrase in rejecting an offer of the kind from Wyndham Lewis), we think the plain facts, many of them freed from distortion or presented for the first time, may provide a refreshingly different image of the painter.

Augustus Edwin John was born in Tenby, Pembrokeshire, on 4th January 1878, the younger son and third child of a family of four. His mother (formerly Augusta Smith, whose roots were in Brighton) died at a very early age. It had been from her, however, not from his father, a Welsh solicitor, that he and his sister Gwen, the elder by two years, inherited their insatiable desire to draw. At the time of Augustus' birth in a seaside boarding-house, Haverfordwest (inland) was still the family home. The motherless children were not moved to Tenby till 1884, and the two budding artists among them endured rather than enjoyed its self-conscious gentility.

A short spell in Clifton, Bristol – not at the College – excepted, Augustus received his education in Tenby; for a few months, in his seventeenth year, at the Tenby School of Art, though he afterwards appears to deny it.² Was it here under the general supervision of the Principal, Edward J. Head,³ or at an earlier stage that a Miss O'Sullivan taught him the smudge-and-stipple way of going about things known as 'stumping'?⁴

The Slade School of Fine Art soon put a stop to this, and for the tightly-rolled paper 'pencil' dipped in pulverized chalk substituted a brittle stick of charcoal much less easy to handle. His son's decision to

¹ Michael Holroyd's Augustus John, the official biography, will be referred to here, from now on, as 'M.H.'.

². . . though I attended no official Art School': Augustus John, 'A Note on Drawing' in Lillian Browse's *Augustus John Drawings* (1941), p. 9.

³A painter of landscape and still-life, Head came to Tenby from Scarborough. He exhibited sporadically at the R.A. between 1893 and 1921.

⁴ Lillian Browse, op. cit., loc. cit.

renounce an Army career in favour of art may seem to have been accepted by Edwin William John with surprising equanimity. In fact, no heavy sacrifice threatened him. It is often forgotten that Augustus was master of a tiny but vital income of £40 a year, perhaps £400 in present-day terms. With this and the remission of fees earned by scholarships and a prize or two thrown in, he could keep his head above water. He arrived in London in October 1894.

The legendary Slade acclamation, 'There was a man sent from God, whose name was John', does not date back to those earliest days in Gower Street. Evidence exists to show that John began as a quiet, painstaking and anything but cocky pupil. The bevy of talented girls was daunting enough. The men students dazzled less; but he stood in some awe of Tonks, the Principal's second-in-command.⁵ It has been the fashion to decry as affected John's highly personal approach to drawing, as if one so well endowed by nature needed – ad captandum – to elaborate a 'style'. On the contrary, the fastidiousness was all objective. The simpler the statement, too, the better pleased the artist. Characteristically, his initial rendering of the Discobolus in the Antique Room at the Slade sported no flourishes of any kind. Its economy almost shocked – before it delighted – the prowling Assistant Principal. What leaped to the eye was a gift for the form-revealing contour which the Slade, following Ingres, regarded itself as pledged to inculcate. Had Tonks been French, instead of merely francophile, he would have fallen on John's neck. Here was the student he had been waiting for.

The advantages for John himself in having Tonks as mentor rouse some doubts. Bedevilled always by a central core of indecision, he was particularly grateful to be led just at this moment. London confused as well as charmed him. Art was still unknown country. Tonks drove his students hard; but John welcomed a discipline he could not have supplied had he been left to his own devices. The industry was there, its direction lacking. But at this distance in time, the drawbacks of becoming Tonks' star pupil are even clearer than the undeniable advantage or two. Because Tonks himself so outshone Steer⁶ as a teacher, what he taught – drawing – acquired an isolated significance, instead of linking up with Steer's sleepy commentary on colour. Tonks' own works in oils or pastel tend to be hesitant and insipid. John could have learned little from them; and as he could learn nothing from Steer either, he seemed doomed to remain (the term was Tonks') a 'methodical' draughtsman and no more.

Then, in the summer of 1897, a serious accident befell him. Bathing off Giltar Point along the coast from Tenby, he struck his head on a submerged rock. The wound, which had to be extensively stitched, was regarded by the doctor who undertook the task as the 'worst of its kind he has had to deal with'. A lengthy convalescence – rather than the blow itself – seems to have unleashed new forces in John. He returned late to the Slade for the 1897–8 session, a changed man. Not only had his appearance altered (he gave up shaving and ceased to clean his shoes): in character, even, this was a *blagueur* and rebel. Strange to relate, the grisly experience he had just been through left him anxious to risk his neck again at every opportunity. In the Life Class, too, scene of only cautious master-strokes up till then, he began to achieve an excellence that positively alarmed: 'methodical' still, but with a streak of madness in the method now.

A sheet of studies drawn about 1897 (Pl. 25) gives us a glimpse of the new virtuosity. It is a Slade exercise and rightly belongs within those grey walls. Here, exalted to an independent art-form, is a rendering of the human body by a 'succession of rhythmical lines following the surface and explaining

⁵Henry Tonks (1862–1937) had been invited by the Principal, Frederick Brown (1851–1941), to join the staff in 1893: this was a daring move, since Tonks' experience had been wholly medical.

⁶ Philip Wilson Steer (1860–1942), at the height of his powers in the late Eighties and early Nineties, had been appointed by Brown in 1892. With Tonks, he remained at the Slade till 1930.

⁷ The victim, in a letter to Ursula Tyrwhitt. M.H., p. 51.

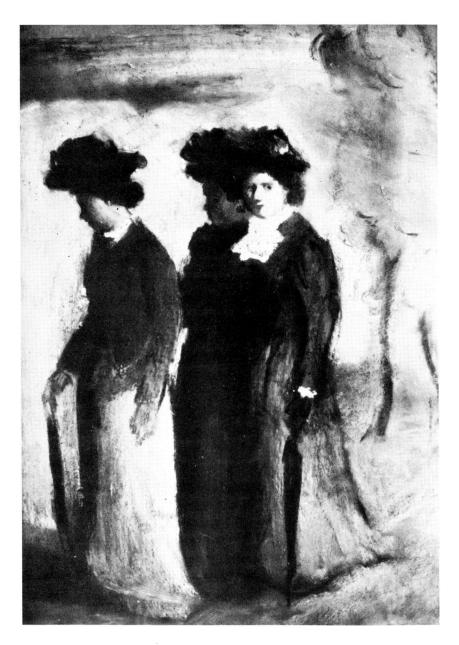

i The Promenade, c. 1900

its structure's which perfectly fulfils Tonks' *religio medici*. No one could have competed with John in such a task – or produced anything at once so brilliant and so hideous.

Fortunately, sitters other than professional models, and from a world outside the suffocating Life Room, soon presented themselves. One of the bonuses of John's convalescent inactivity was that the boredom and loneliness of it seem to have put to flight all his former shyness. Gwen had arrived at the Slade in 1895. The once daunting band of girl-students led by the sisters Waugh (Edna and Rosa) and by Louise Salaman could not be expected to withstand the entreaties of an always handsome and now bolder Augustus; and their portraits must be numbered among his most sympathetic early works.

⁸ Lillian Browse, op. cit., p. 10.

With Gwen, on one occasion, posed a couple of the Slade's particular beauties, Ursula Tyrwhitt and Ida Nettleship (Pl. 26). Both, at different times, might be called objects of his 'unhesitating devotion's: an Augustan phrase not to be confused with any irrevocable plighting of one's troth. The drawing is in pencil. Whatever the superior richness of charcoal, its breadth and warmth, pencil was to be John's most characteristic medium. For some reason, this is held against him, as was a predilection for the small sable against Stanley Spencer. Both tools, it has been supposed, ration the full vigour of genius. One cannot actually observe that they do. In fact, the drawing just mentioned has none of the suavity, offensive to the same critics, of the long procession of silvery Dorelias which was to follow later. Nor do the lines in this group-portrait obediently hug the surface and report on structure. They are as higgledy-piggledy as Sickert's, in adapting themselves to a new topic. No swooning arabesques here, but a multitude of short, coarse jabs with the pencil, blunt for preference, oblique and crosshatched without reference to the underlying form.

A number of other drawings traceable to the late 1890s survive to show the artist's independence of what, through his own influence, was coming to be known as the 'Slade manner'. O Sometimes they are hardly recognizable as John's. He was searching for the ideal medium. In several fancy pieces, particularly rustic idylls (of which the Tate has an example), he tried his hand at pastel. It may be that voluntary departure from easy elegance had to do with first experiments in etching, where it is not in the needle's power to sustain a single, expressive line for very long.

Sir William Rothenstein no doubt saw the thing in correct perspective when he wrote, years later, that while John's 'drawings and pastels got better and better', about this time, 'his painting was still uncertain; he found it difficult to control his palette, but now and again he gave promise of astonishing genius'. Where painting was concerned, John had, in one sense, no master; in another, too many masters. An uncertain colourist himself, Tonks was a strong advocate of what could be picked up through constant visits to the National Gallery and other public collections. John returned from these visits bewildered, his head swimming with Rubens, Rembrandt and Watteau. To pass out of the Slade with the highest honours, he had to score one resounding triumph in oils. It is not astonishing that, having concentrated all his remarkable powers on winning the Summer Composition prize of 1898, he easily succeeded; nor that the result proved very much a pastiche of the masters dearest to him.

But we are not for that reason obliged to dismiss his 'Moses and the Brazen Serpent' (Pl. 28) as a feeble echo. In the circumstances, it may be reckoned a wonder of wonders: that is, given John's age (under twenty-one) and the poverty of Slade painting-instruction in the hands of Steer and W. W. Russell.¹² At a recent exhibition in the Royal Academy Diploma Galleries,¹³ 'Moses and the Brazen Serpent' could be seen hanging next to Gwen John's 1900 self-portrait, now owned by the Tate Gallery. This juxtaposition prompted some mock-sympathy for Augustus on the part of the cataloguer: one cannot think why. Of course, we all enjoy Gwen's painting of herself in cameo and tartanstriped blouse. But it is a small picture (less than eighteen inches high) and, of its very nature, intimate and inward-looking. Her brother's 'Moses' was planned – quite properly – as a public demonstration of his powers and occupies a canvas five feet by seven. To 'do Poussin over again', to out-Rembrandt Rembrandt, was Augustus' prime business here. Naturally, he failed in that endeavour, but he gave

⁹ The words are inscribed on a drawing in the British Museum, given by the artist to a 'Miss Emily'.

¹⁰ Several early self-portraits and at least three Slade-period drawings of Gwen (one in the Archive of the National Museum of Wales, the others belonging, respectively, to Mr Michael Salaman and Mr John Lumley, are well known to us) display the harsher approach.

¹¹ Sir William Rothenstein, Men and Memories (1931–2), Vol. I, p. 340.

¹² Later, Sir Walter Russell (1867–1949), Assistant Professor at the Slade from 1895 till 1927.

¹³ The Slade, 1871–1971: a Centenary Exhibition, 20th November-12th December 1971.

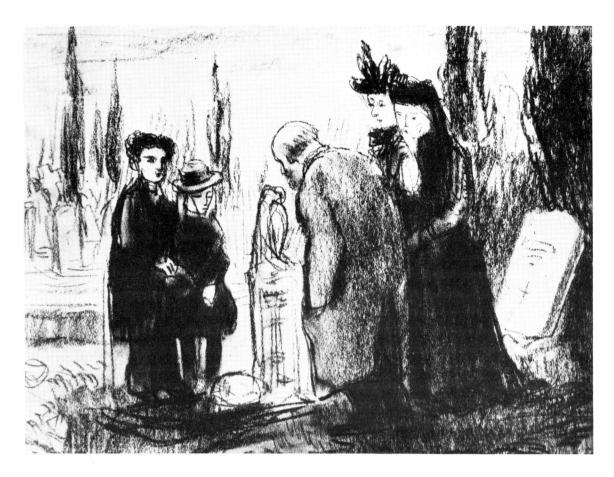

ii Churchvard Scene, c. 1901

his large-scale decorative ambitions a notable first airing and attained a fine, blond harmony and a subtle texture of paint throughout. The more often this derided work leaves cold storage the better, in fact. One has only to look at the next prize-winning composition, the much vaunted 'Hamlet' by young William Orpen,¹⁴ to perceive the difference between precocious mimicry and a student's genuine determination to learn from the best models.

Oddly enough, the surfeit of explanatory gesture which somewhat tries one's patience in 'Moses and the Brazen Serpent' points also (if we are right) to an admirable, and in 1898 quite extraordinary, appreciation of El Greco. Paris was then the capital of the art world; yet Arsène Alexandre tells us that there were probably not more than ten men in that city during the last decade of the century who knew or cared about the Toledan master. ¹⁵ John visited Spain for the first time in the spring of 1922, and his enthusiasm never waned. It was all very well for him to poke fun at 'two gigantic old gentlemen [presumably, the 'St Andrew with St Francis' in the Prado], lightly clad in paper dressing-gowns' tripping 'buoyantly in a landscape of cork and bottle-green, under the illumination of a gibbous moon

¹⁴ To give it its full title: 'The Play Scene from Hamlet'. It is even larger than John's entry, and now hangs in Houghton Hall, Norfolk. Sir William Orpen (1878–1931) was a student at the Slade from 1897–9.

¹⁵ The El Greco craze really began in 1902, with an exhibition of his work at the Prado, Madrid. A. F. Calvert and G. C. Huntley's monograph appeared in Calvert's *Spanish Series* in 1907, Barrès' in 1912 and David Katz's *War Greco astigmatisch?* in 1914. A plethora of works on the subject followed after the First World War and has continued ever since.

which shines balefully between the incandescent shuttle-cocks of a sky in uproar'. ¹⁶ Frivolous himself, when under the Greco influence, John indulged eccentricities which, being at second hand, are a good deal less easy to pardon. He could have been more sparing with the imitative upcast glances, the spavined knees, the flourish of excessively tapered fingers and the very limited repertory of contrapuntal poses borrowed from El Greco's Roman portfolio. But to be sparing was not John's way.

He left the Slade in the summer of his 'Moses and the Brazen Serpent' triumph, and there followed an interlude of feckless industry, during which his chosen companions were most often Orpen – 'Orpsie-boy', self-styled, a stage Irishman almost, but having a hard enough head for business – and Ambrose McEvoy; ¹⁷ with the indefatigable Will Rothenstein always helpfully at hand. In Will's wake came his brother Albert, and Charles Conder, of whom Will painted what is arguably the finest of all portraits of the 1890s. ¹⁸ John's departure from the silhouette, typified by this canvas, of attenuated silk hat and hour-glass, ankle-length overcoat finished off by a pair of sparkling pumps, cuts him adrift at once from the Beardsley world of 'Lady Gold's Escort'. In the heyday of the Decadence, John was never of it. Whistler, its father-figure, whom he met through Gwen, made little impression upon him. When the opportunity came to join the circle of flatterers round Wilde, an evening or two was as much as he could take. Though addicted to café life, especially to that of the Café Royal, John had constant need to fill his lungs with copious draughts of fresh air.

In this respect, Rothenstein's shadowy glimpse of him, in the summer of 1899, posed with Alice Rothenstein for the picture called 'The Doll's House', is highly uncharacteristic: he couldn't, one feels, have remained at the foot of that cramped staircase in the stifling little hall a moment longer, even with Alice's agreeable good looks to console him. ¹⁹ He swam prodigiously, during this stay near the Channel coast, and the drawing he did was all out of doors.

Nevertheless, John would have to continue a prisoner of cities for a while yet. It is the artist's – and particularly the young artist's – fate that he must live where he can sell his work. John had had his first one-man show at the Carfax Gallery in the spring of 1899. Backed by D. S. MacColl,²⁰ whose goodwill expressed in *The Saturday Review* was very well worth having, he sold enough to think himself successfully launched. In the same year, at its summer and winter exhibitions, the New English Art Club accepted a total of four drawings. Though rather less hostile to the Royal Academy as the years passed (and this was the Club's thirteenth), it offered wall-space to almost every anti-Establishmentarian from Stanhope Forbes²¹ to Sickert (even welcoming Beardsley in his brief hour of health and strength). Promising Slade students had an entrée to the N.E.A.C. through its Secretary, none other than their Principal, and through two other members of the Gower Street staff, Steer and Tonks. No 'faithful dog', as he expressed it, in affairs of the heart, John had a strong professional sense of loyalty, and he remained a regular exhibitor with the Club for the best years of his working life. But showing

¹⁶ Augustus John, *Finishing Touches*, edited and introduced by Daniel George (1964), p. 134. These notes, entitled 'The Prado Revisited', were composed as late as 1954. The 'St Andrew and St Francis' remained unknown until 1937 and did not enter the Prado until 1942. In spite of the irreverent manner in which El Greco is here discussed by John, the spell was never quite dissolved.

¹⁷ Ambrose McEvoy (1878–1927) entered the Slade in 1893: he became a fashionable portrait-painter. His wife, Mary Spencer Edwards, was also a member of the Johns' circle, and Augustus did some notable early drawings of her.

¹⁸ Albert Rutherston (1881–1953) changed his name from Rothenstein during the First World War. He arrived at the Slade in 1898 and won the Summer Composition prize himself in 1901. Charles Conder (1868–1909) had no Slade connexions. Rothenstein's portrait of him, of 1892, is in the Toledo, U.S.A., Museum of Art.

¹⁹ In the Tate. A scene from Ibsen's play is intended, John playing Krogstad, Alice Rothenstein Mrs Linde.

²⁰ Dugald Sutherland MacColl (1859–1948), champion and biographer of Steer, and later Keeper of the Tate Gallery and the Wallace Collection.

²¹Stanhope A. Forbes (1857–1947), chiefly associated with the Newlyn School and paintings of Cornish seafaring life. For a fresh examination of the N.E.A.C., its later connection with the Slade, and a complete list of John's contributions to its exhibitions, see M.H., pp. 109–113 and Appendix.

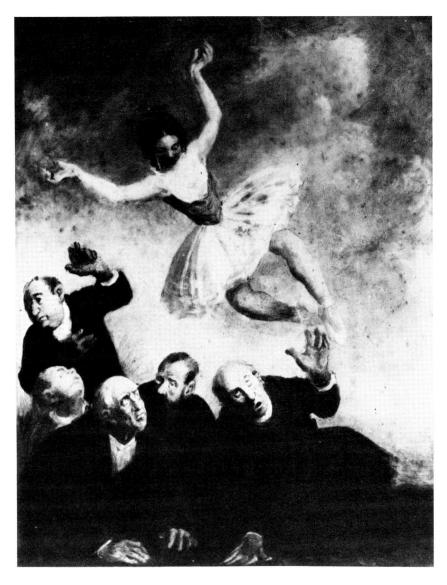

iii Désespérance d'Amour, c. 1902

and selling an occasional drawing, or even a sheaf of drawings, wasn't sufficient to keep him.

Still less the two of them: for on 12th January 1901, with McEvoy, Evans and Gwen as witnesses, he married Ida Nettleship.²² His indigence had hitherto required no apologies, but under the Nettleships' disapproving eye it began to embarrass him. Thus, when MacColl was asked to suggest someone for the post of instructor at an art school affiliated to Liverpool's University College, John, after some natural hesitation, allowed his name to go forward.²³ He was offered the job and accepted it, arriving in Liverpool with Ida very early in 1901. Artistically, the importance of this migration cannot be

²²This relationship began at the Slade. Ida Nettleship was the daughter of Jack Nettleship, an animal painter in the tradition of J. M. Swan and Briton Rivière, but less successful. Her mother kept the pot boiling by designing and making dresses, in particular for leading personalities in the theatre.

²³ He was never, as has often been stated, Head of a University Department of Fine Art, nor occupant of a Chair. (Liverpool achieved full university status only in the summer of 1903, a year after the Johns' departure.)

overestimated. Among its results was the pile of copperplates which established him at once as a master of the etching medium. Something much less predictable, however, was to be born out of Merseyside pea-soupers and the drab grove of Academe on Brownlow Hill: something gay and grand. Here began in earnest the Romany cult. The persistence of this theme through the years is as remarkable as the suddenness of its coming to life. All at once, we may say, the song in John's heart expanded from a mere nationalistic *Mae Hen Wlad Fy Nhadau* to a Schubertian *Das Wandern*, the young artist accepting as the Land of his Fathers any wild shore or stretch of desolate heath patronized by the Gypsy-kind.

Fallen now into disrepute as the province of photographic hacks, etching has more than once served the noblest cause. Rembrandt's free play of invention on the copper held up to ridicule the elaborately systematized plates issued by the royal (and Papal) presses of his day. In the late eighteenth and early nineteenth centuries Goya and Blake, each in his different manner, used the technique with subtle polemical effect. Later in the nineteenth century, and in the hands of men like J-F. Millet, Charles Meryon and Rodolphe Bresdin, it became one of the most telling instruments in the attack on materialism. In England, John's ageing contemporary Whistler waged with it his personal war against British bad taste, rejecting for a fastidious delicacy of touch the crude approach that marked his own philistine beginnings as a naval cartographer in the United States. Added to which, the introduction of photomechanical processes during the 1880s had more to do with the revival of etching as a studio activity than has been generally supposed, just as the discovery of the zincograph gave new prestige to non-commercial wood-engraving.

Such historical considerations are not irrelevant, for if John took to etching like a duck to water, it was at least in part because he adored Rembrandt, Goya and Millet, could be as spookily Romantic as Meryon and as sentimentally Realistic as Bresdin. And no one of his generation was able to ignore the exquisite series of plates etched by Whistler in London and Venice, together with portraits and figure-studies less open to criticism than the Master's later oils. ²⁴ Etching, too, as has just been said, had become the traditional vehicle of the rebel; and the bearded, be-ringed, moleskin-suited John who arrived in Liverpool for the spring session of 1901 was certainly that. Nor must one forget either the part played by Benjamin Evans, ²⁵ his fellow-student and crony at the Slade, in first acquainting him with the mysteries of the acid-bath, or – a determining factor, perhaps – the existence in the Brownlow Hill art school of the essential but least easily acquired item of printmakers' equipment, an etching-press.

Evans received his reward in the form of a portrait, thought to be John's opus no. 1 in this field (Pl. 27). It survives in two impressions, a rare, light print and a second, from the rather heavily-inked later state. But competing with this for first place are the three square inches of copper bearing a Rembrandtesque self-portrait and signed and dated on the plate 'John 1901'. ²⁶ Indeed, this introductory period is Rembrandt, Rembrandt all the way, Liverpool's seedy supernumeraries – 'The Mulatto', 'The Old Haberdasher', 'Old Arthy' – standing in for Amsterdam's and culminating in an 'Old Man in a Fur Cloak' straight out of the Jodenbreestraat. That the plates are tiny and the persons figuring on them captured sight-size reinforces the Rembrandt comparison: not much to John's

²⁴ Less open to John's criticism, that is. Whistler's tentativeness on canvas during his old age led John to an apt, if cruel, comparison with Balzac's Frenhofer, a fictitious painter who lingers so long over his work that nothing intelligible ultimately emerges from it. Ironically, the problem of not knowing where to stop would equally afflict John himself.

²⁵ Benjamin Evans was a boyhood friend of John's, having attended the same private school at Clifton. With McEvoy he made up a threesome on sketching expeditions.

²⁶ The proof we examined in the National Museum of Wales was marked 'John's first etching'.

advantage, for he has neither his hero's insatiable curiosity nor his patience. There is as little variation in technique as in subject-matter, and fine early states too often disappear under the burr ploughed up by reckless afterthoughts in drypoint.

Though such an example as the celebrated and slightly larger 'Tête farouche' (Pl. 29)²⁷ shares these weaknesses, too, it expresses a dash and abandon that are wholly John's, and further suggests the 'wild man of the woods' constantly in dispute with the salaried art-teacher. John Sampson²⁸ (Pl. 31),

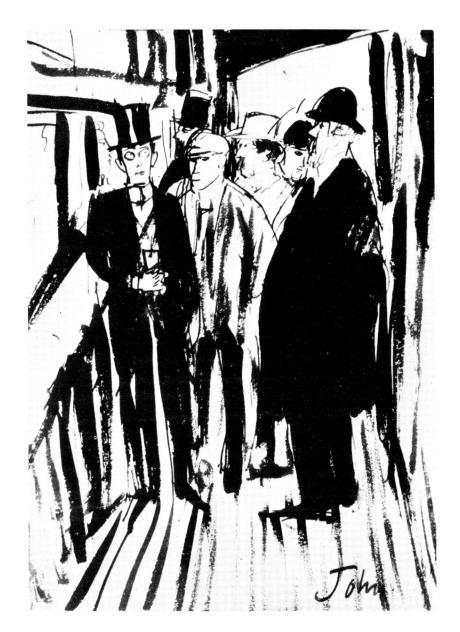

iv Spectators in a Picture-Gallery (?), c. 1912

²⁷ No. 10 ii, in Campbell Dodgson's *A Catalogue of Etchings by Augustus John*, 1901–1914 (1920). The later state, not shown here, is heavily slashed with drypoint.

²⁸ John Sampson (1862–1931). Appointed in 1892, he remained at the University College and the University for thirty-six years.

the Liverpool University College Librarian and national expert on Gypsy words and ways, became the artist's favourite companion. 'Under his tutelage and by personal contact with the Gypsies,' John wrote later, 'I soon picked up the English dialect of Romani.'²⁹ Sampson took John with him on expeditions to Romany camps at Aintree and on the Wirral; and a portrait of Walter Boswell, kinsman of Watts-Dunton's Rhoda, makes its appearance among the early etchings. The Liverpool episode is closely examined in Michael Holroyd's biography of John.³⁰ Here we need do no more than record the artist's inevitable wearying of the three days' teaching a week, as well as – Sampson, Mackay and Kuno Meyer excepted³¹ – of the stuffy little College circle. Out of patience at times even with Sampson, a *Rai* who indulged some excusable delusions of grandeur, John and Ida discovered a more endearing kindred spirit in Mary Dowdall, daughter of Lord Borthwick and wife of an ambitious Liverpool lawyer whom we shall meet again in these pages.³² Gypsies and aristocrats have a spacious way with them: picketed middle-class domesticity filled John with horror. In January 1902 Ida's first child, David, had been born. Though welcoming the event, the artist trembled for his freedom. When Ida left Liverpool for a short visit to her ailing father in the spring of that year, he wrote to Will Rothenstein: 'Decidedly it is inspiring to lie alone at times. I fear continued cosiness is risky ³³

With the aim, therefore, of escaping the deadly tentacles of this cosiness, the artist gathered up his family and left Liverpool for London in July 1902. The return without regular salary to Fitzroy Street and its happy go-lucky economy increased, of course, his need to find solutions to the financial problem. In another form, teaching itself would have to be resumed. Ida was again pregnant. If the butcher and baker (devil take the landlady!) were ever to get paid, tiny images on copper would have to give way to more acceptably-sized equivalents on canvas. It had already become obvious that John, a natural catcher of likenesses, must expect to earn the best part of his living as a portrait-painter. Though he lacked the tricks of the trade, he was often enough, if glumly enough, going to pick up his palette for the same purpose as the years went by.

Consider his current diploma-pieces in the vein. There was the initial commissioned portrait of 1899, the anonymous 'Old Lady' (Pl. 1).34 She lived in Eaton Square: scanty information, but still worth having. For it reminds us how, even at the earliest stage, the anti-social John managed to land feet first in the midst of the most enviable of all quarters of patronage in London, that which divides Sloane Street from Grosvenor Place. Belgravia was a world of high ceilings as well as great wealth, and most of these town-mansions (before so many of them were snapped up as embassics) had their twin establishments in the country, with walls similarly able to accommodate canvases of Sargent-style dimensions and splendour. The 'Old Lady', however, does not woo us like Sargent's sleek 'Mrs Asher Wertheimer'. She is all dignity and reserve. A single patch of scarlet, the cover of the book she holds, acts as foil to the sombre background and sitter's black silk gown. It is sad to read John's almost contemptuous dismissal of the picture in *Chiaroscuro*, revealing his utter incapacity to distinguish

²⁹ Augustus John, Chiaroscuro, Fragments of Autobiography: First Series (1952), p. 58.

³⁰ M.H., Ch. III, passim.

³¹A sensitive sketch (untraceable now) of Sampson is reproduced in *Chiaroscuro*, facing p. 58; John's portrait of J. M. Mackay, Rathbone Professor of Ancient History at Liverpool, is a particularly fine one; and that of Kuno Meyer the eminent Celtic scholar – Pl. 52 – is perhaps the most impressive example of the artist's work in the National Gallery of Ireland: see our footnote 49, p. 21.

³² Harold Chaloner Dowdall, later County Court Judge and Lord Mayor of Liverpool, became a few years later the subject of the grand, formal portrait rejected by Liverpool and now in the National Gallery of Victoria, Melbourne (Pl. 49).

³³ M.H., p. 134.

³⁴ Thought by Mrs Arthur Clifton to represent John's landlady (!), the picture was rediscovered by the then Director of the Tate Gallery in 1941 and added to its collection. See also M.H., p. 85.

³⁵ Chiaroscuro, p. 147. This incapacity was the cause of great embarrassment to those who, like Mr Brinsley Ford, attempted from time to time to bring together an anthology of his best productions.

between good and bad in his own work.³⁵ Indeed, he was to sheer right away from this Pre-Raphaelite attention to detail – and too often, more regrettably, from the warm sympathy for his sitter which (in spite of his protests to the contrary) seems to light up the features, Rembrandtesque again in their golden hue, of the frail but still formidable dowager in her *petite coiffe*.

John's next portrait of consequence, 'Merikli' (Pl. 30), was hung at the N.E.A.C.'s 1902 winter exhibition. The anxieties inseparable from a commissioned work did not bother him here, for his model was Ida. Like several early portraits of favourite sitters, particularly of this one, the painting is carried out almost as a pastiche of a seventeenth-century master: is it Rembrandt, Velázquez or one of those Roman or Neapolitan artists hardly known to the British public until after the Second World War?36 Whatever the answer, 'Merikli' was perfectly acceptable - indeed, reckoned fresh and exciting - in its own day. The dark, almost masculine beauty of the head, the exquisite painting of the left hand, naturally made a deep impression. And yet the picture is more curious than attractive. Those who turn to the account of John's married life will find themselves wondering what, consciously or unconsciously, the artist was saying here about the courageous but often uneasy partner of his moods and vagaries.³⁷ They will be puzzled that out of her plaited-straw basket, stock-in-trade of Zurbarán and Caravaggio as well as of the Gypsies, and loaded with finer blooms, Ida selects and proffers a simple daisy. If the gold band on her finger is what it appears to be, a wedding-ring, then why does she display it so proudly to the spectator on the wrong hand? At least it has been possible to settle the meaning of the word 'merikli' (Note to Pl. 30). Yet there was sufficient of John's aggressive character as a painter in this ambiguous and not altogether satisfactory mixture of old and new for the work to be acclaimed by the N.E.A.C. its Picture of the Year.

The honour done it may seem the more remarkable when we remember that 'Merikli''s companionpiece at the 1902 exhibition was the portrait of Signorina Estella Cerutti (Pl. 4). Very conveniently, we have been able to examine the two works side by side in the City Art Gallery, Manchester. They are utterly different in technique and spirit. At odds with the old-masterish pose and Stradivarius browns, Ida's features are laid in broadly and spontaneously and without the least regard for elegance. In the painting of the Signorina, on the other hand, all is subordinated to sinuous contour and an ultra-refined mapping of the shadows. The 'Merikli' might have been inspired by Hals, the 'Estella' by Ingres. Excellent proselytizers both: but for John to swing between antithetical poles in one and the same year suggests an artist in a quandary. He was still, in fact, in search of an idiom of his own. Other dilemmas, too, of the heart rather than the hand, are suggested here. Of the pair, it is the wife who lacks self-assurance. Estella, or 'Esther' (she lived, easily summoned, in the same house in Fitzroy Street), fixes Augustus with a glance, long and languorous, in which the certainty of pleasing is rendered more piquant by the ballooning curves of her ribbed muslin dress. Indeed, the whole creamy-gold silhouette, which takes in the sitter's clasped hands and trailing handkerchief, provides an irresistible effect of movement: so that, with the Signorina, we seem suddenly to glide forward – up to and just across the threshold of the twentieth century.

It was not, however, till the following year, 1903, that John met Dorothy McNeill, the 'Dorelia' whose discovery led to his first unequivocally personal work, from charming little studies like the early 'Ardor' (Pl. 5) to the magisterial set-piece called 'The Smiling Woman' (Pl. 9). This time, Ida's dilemma was to be resolved only by her death, which took place in Paris, in 1907.

³⁶John certainly appears to have been drawn to the Caravaggisti, employing at the same time many contradictory features of Mannerism. We have come across only one painting of Ida, that belonging to Mr and Mrs John Gardner (Pl. 2), which, though still emerging from brown shadow, seems genuinely of John's own day.

³⁷ M.H., pp. 113–154.

2 5

A FTER HIS return from Liverpool to London and hoping to 'make pocket-money out of it at least', John decided to join forces with Orpen in founding an art school in Chelsea. His own privacy was secured nearby at 4 Garden Studios, Manresa Road: an arrangement which, despite its convenience, left him characteristically ungrateful. He hated (he could also, he sometimes forgot, love) London. 'A studio,' he growled, '—what is it? . . . 'tis a box wherein miserable painters hide themselves and shut the door on nature '2

By the summer of 1903, when he wrote in these terms, an escape-route had been organized. Ida, with her boys David and Caspar (Robin would be born in the following year), settled into Elm House, Matching Green, Essex, where Augustus joined them from time to time. The small children in a hitherto unpublished sheet of pencil-studies (Pl. 33) may represent the David and Caspar of this cra. If so, it provides a foreglimpse of the long series of sketches and more deliberate compositions in which John's sons – they reached, at one point, a total of seven – serve as models, either by themselves or in company with his womenfolk.

Just as there is a hunter's moon, so perhaps we can speak of a painter's moon, when daring, skill and opportunity are all in miraculous accord. For John, this splendid moment extended from Dorelia's first appearance in his life³ to the outbreak of the 1914–18 war.

Beyond its almost exclusive concentration on his own children and womenfolk as models, the period is remarkable for its open-air settings, for it was now John's aim to live in high Gypsy fashion. In 1905 he took a positive step towards the realization of his desires by acquiring a picturesque, 'cottage'-style van from an old Slade-School crony, Michel Salaman.⁴ Late that April, or early in May, it provided shelter and seclusion for the birth of Dorelia's child. But soon after the arrival of the baby, the seraphically beautiful Pyramus (Pl. 12), they were joined by Ida, with her own sons, and by John himself. The site was Dartmoor; and there survives one little sketch of the distant caravan, dark against a late-evening sky (Pl. 34), that is both romantic and eerily reminiscent of Conan Doyle's description of the place in his *Hound of the Baskervilles*, then not long published. In another, much larger canvas, the two mothers and their children pose together beside the dipped shafts of the *vardo*.⁵ Most evocative of all, and now in a private collection, is a second oil sketch, showing the same group in

¹Orpen played the leading rôle: John himself taught for one day a week only. The establishment, with Rothenstein's brother-in-law Knewstub as secretary, opened in the King's Road for the autumn session of 1903, and was called, not very daringly, 'The Chelsea Art School'.

² In a letter to Will Rothenstein. M.H., p. 180.

³ She did not become a permanent member of his household till towards the end of 1904.

⁴Salaman died, in his nineties, in 1971. At the R.A., 1954 (No. 373), was a portrait of him in hunting pink entitled 'The M.F.H.', for he soon gave up art to return to the normal recreations of a country gentleman.

⁵ Reproduced in John Rothenstein, *Augustus John* (1945, 2nd ed.), Pl. 6: now in Lord Cowdray's collection. *Vardo* (Romani) = van.

bright sunlight framed by the dark opening of a tent (Pl. 6). In the two latter pictures, the artist leans over the caravan's half-door, smoking his clay pipe, the perfect Romany Rye.⁶

All this, however, was in the nature of a vacation. A grudging traipse-back had to be made to sordid street and claustrophobic studio. But the school in Chelsea wearying him, and France calling with a new insistence, John decided he had had enough of London for the moment; thus, though the Elm House lease had not quite run out, he removed women and children and himself *en bloc* to Paris, where he rented a studio in the rue Dareau, Petit Montrouge, on the southern outskirts of Montparnasse.

France had called to John – with whose voice? A stronger French influence has been noticed in his work about this time by connoisseurs on the other side of the Channel as well as by our own.⁷ John's numerous private utterances on the subject confirm the principal source of inspiration: apart from what was freely available in reproduction, he seized every opportunity to familiarize himself with Puvis de Chavannes' large decorative paintings, all carried out during the 1880s and 1890s, in the Sorbonne, the Hôtel de Ville and the Panthéon. Never is the quiet lyricism of these canvases (for such they are: not frescoes) interrupted by any of the brash, fortissimo passages characteristic of John. On the other hand, both Puvis and his Welsh admirer subscribe to the same canon of Meaninglessness9: the picture is the thing, its message a secondary affair. And we can easily recognize a blood relationship between the gesturing dreamers of the Paris decorations and Ida and Dorelia, forever waving explanatory hands (explaining nothing) while the babies scream and the milk boils over. Even Campbell Dodgson's enthusiasm petered out at times in the somnolent presence of these belles paresseuses abstractedly gathering to themselves an enigmatic Caspar or a sulky Robin. It was under pressure from Dodgson, however, that John produced an avalanche of freshly-etched copperplates in 1906. Their purpose was twofold: to add to the corpus of prints Colvin¹⁰ had begun to collect for the British Museum, and to fill the walls of an exhibition-room at the Chenil Gallery.¹¹ From the historian's viewpoint they are of little interest, though there creep in some further souvenirs of the Dartmoor visit. In portraiture, the crisp likeness of Wyndham Lewis, ¹² of an earlier date (Pl. 32), as indeed that of Benjamin Evans, first portrait and plate of all, would never be improved upon. The dependence on Rembrandt, at the same time, noticeably slackens.

John did much more than slough off the seventeenth century by his thirtieth year. With a wild leap he landed in the present. The vogue for the Primitive certainly fascinated him. Looking through a cache of his ephemeral sketches recently, we were struck by the heavy incidence of Easter Island heads, doodled on scraps of paper, which must date from the early 1900s. The attempt to break away

⁶The caravan craze, as part of a widespread Gypsy cult, is discussed in Malcolm Easton, *Augustus John: Portraits of the Artist's Family, Catalogue of an Exhibition*, etc. (1970), 'Wheels within Wheels', pp. 43–59. One can add that by 1908, with the publication of Kenneth Graham's *The Wind in the Willows*, this craze penetrated the nursery.

⁷E.g., René Gimpel, in his notes on the Quinn sale of 1927 (*Journal d'un collectionneur*), speaks of 'trop de réminiscences françaises'.

⁸In letters to Alice Rothenstein and Alick Schepeler (see footnote 15, p. 15), only a year later, he could refer to Puvis as the 'finest modern' and speak of revisiting the Panthéon 'to encourage myself with a view of Puvis' decorations'. M.H., pp. 253 and 224.

⁹Though few of us like *every kind* of 'meaninglessness' in John's work *at all times*, it is of the essence of his art. Nor, as has often been suggested, can it be written off as an old-fashioned or reactionary trait. In fact, had John bothered to lay down the principles of his attitude in print, they would read today quite as impressively as Clive Bell's analysis of 'significant form'.

¹⁰ Sir Sidney Colvin (1845–1927), then Keeper of the Department of Prints and Drawings at the British Museum.

¹¹There were two exhibition-rooms at the Chenil Gallery, directed by Knewstub, who had purchased premises (with Orpen's help) next to the Chelsea Town Hall in the winter of 1905. One of these rooms housed a permanent collection of the McEvoy–Orpen group. John exhibited his etchings in the other, in May 1906. The show proved a great success.

¹² Percy Wyndham Lewis (1884–1957) was introduced to John in the summer of 1902. The rich comedy of their relationship was first dealt with in Michael Holroyd, 'Damning and Blasting', a radio talk, published in *The Listener*, 6th July 1972. See also, M.H., pp. 139–142. John's two fine etchings of Lewis belong to 1903.

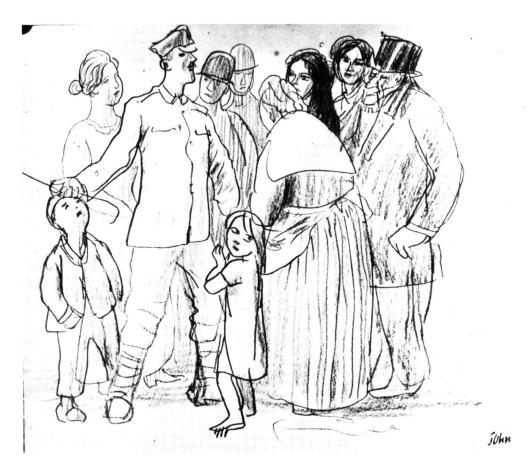

v The Bragging Soldier, 1915

from what is now regarded as an excessive facility in rendering the superficial appearance of things, to stop being (as his contemporaries termed it) an 'ill-mannered camera', to change his whole approach, in fact, may be connected with the tragic death of Ida, following the birth of her fifth son Henry, ¹³ on 14th March 1907. While the artist appeared to armour-plate himself against grief or self-reproach, he had passed through an experience which left the world a different place. And to describe this different world artistically, some changes of procedure were called for.

By April, he was explaining to Rothenstein his need to abandon models, to paint phantasy-figures, Polynesian-eyed. These, he told Will, entered into a primeval vision which included mighty 'chanting in the flushing palm tree groves' and 'thumping of the great flat feet of ecstatic multitudes' aglow with sacred oil. Quite logically, John's first French exemplar, Puvis de Chavannes, had been followed by Gauguin and then by Picasso – the painters of 'Te Reriora' and 'Les Demoiselles d'Avignon' having both expressed their debt to Puvis' 'Le Pauvre Pêcheur'. The year of Picasso's crucial 'Demoiselles', this same year of 1907, witnessed a meeting between the two men. 'I saw a young artist whose work is

¹³ A fourth son, Edwin, had been born soon after the Johns' arrival in Paris, in November 1905. Henry, whose birth Ida survived by only five days, was brought up by the Nettleship family. He died in 1935, drowned off the Cornish coast. ¹⁴ M.H., p. 258.

wonderful in Paris,' wrote John, on 5th August, to Henry Lamb; ¹⁵ and not long afterwards he was confirming this first impression (to which the 'Demoiselles' most forcefully contributed): 'Picasso is a wonder!' ¹⁶ The immediate results may be seen in a few large, lugubrious canvases so untypical of their begetter in most people's minds that they caused a good deal of astonishment at the Studio sales of 1962 and 1963. ¹⁷ In a 'Peasant Woman with Baby and Small Boy' (Pl. 42) John has banished the sinuous poses most tempting to him. The red-haired mother is dour, charmless and uncomfortably rectangular. The 'outcast' note has been sounded with as much emphasis as in the string of similar subjects already carried out by Picasso; and the maternal feet, flat enough certainly, thump one of those lonely beaches so often to be seen in the works of the young Spanish master. A 'French Fisher-Boy' (Pl. 7), of even greater dimensions, can be seen in Mr and Mrs Tumim's Collection. Will the critics ever warm to this aspect of John's talent? One may shrug it off as too derivative, yet there is an act of self-immolation here that demands our respect. Endlessly dissatisfied with his own pleasing gifts, he was to return again and again to the austerity and simplification practised by the early Picasso, most notably, though not particularly successfully, in the vast 'Mumpers' (Pl. 55), now in Detroit.

There were important events on other fronts in 1907. He met for the first time Dick Innes, a brother Celt whose personality soon exercised a powerful spell over him. And he paid an initial visit to Ireland, to stay with Lady Gregory at Coole Park, so that studies could be made of a fellow-guest, W. B. Yeats. At least one fine etching resulted, and more than one oil portrait, with the inscrutable touch required by their hostess. The best – and the least fey – is undoubtedly that in the City Art Gallery, Manchester (Pl. 8). If the object of his going to Ireland had been, quite simply, to make some much-needed money, there were unexpected fringe-benefits. The beauty of the countryside, Yeats' fairy-lore, and Lady Gregory's researches into the language of the Irish tinkers (Shelta, strictly, but having close affinities with Romani), ended by captivating him. Ireland he would return to many times, its peasant-girls and fishermen taking on, though less perceptibly as the years went by, something of the character of Picasso's Blue and Rose Harlequinades. Even the Manchester Yeats is provided with one of those 'viridian vistas' which had been part of the vision communicated to Rothenstein.

No doubt, these stylistic flirtations helped to prepare the way for the full-length picture – unadorned simplicity, in terms of form – of the woman who had succeeded Ida as manager of his affairs and mother-general to all his children, the bright particular Dorelia of 'The Smiling Woman' (Pl. 9), painted in 1908 and probably the most familiar of all John's works. So familiar was this animated *genre*-portrait for at least twenty-five years after its first appearance at an 'Exhibition of Fair Women' at the New Gallery, in February–March 1909, ¹⁹ that those who directed public taste grew to resent its

¹⁵ Henry Lamb (1883–1960) was for long the artist's favourite disciple, modelling himself on everything that was most flamboyantly Johnian. Being equally mercurial, and often a rival for the same women's favours, Lamb outlived his original warm welcome. His wife Euphemia shared with Alick Schepeler a first place among John's subjects for pencil-sketches outside the family circle itself.

¹⁶ M.H., p. 273.

¹⁷ At the first of these Christie sales, 184 items were put up for auction; at the second, 173. After this, we still counted exactly 100 paintings in a warehouse in Salisbury many of which were later acquired by the National Museum of Wales. Few, even among art-lovers, realize both the prolific and the self-critical character of the artist which led him thus to hoard and hide during his lifetime.

¹⁸James Dickson Innes (1887–1914) painted mainly landscapes, especially Welsh ones. Their character is harsh and subdued in colour; and though many are supposedly actual views, as of Mount Arenig (there is a typical example in the Hull University Art Collection), most are imaginary. He shared with Picasso a preference for the non-retinal image, which may account for the same envious admiration felt for him by John.

¹⁹ Roger Fry initiated the chorus of praise in *The Burlington Magazine*, in 1909. In 1930, it could still be chosen as the colour frontispiece for Sir Joseph Duveen's *Thirty Years of British Art*.

ebullient vitality, its almost indecent powers of mesmerism. The picture was withdrawn to the vaults of the Tate Gallery where, a little anxious that the fire might have gone out of it and only the flourishes remain, we were privileged to have the vast canvas hauled out for our inspection. It is pleasant to record the delight aroused in us by what we saw. Many people share Wyndham Lewis' perfectly understandable prejudice against the Gypsy themes that engrossed John about this time: the sterner draughtsman found them altogether too stagy. And nothing could be more stagy than 'The Smiling Woman'. At the top of Lewis' proscribed list, therefore, she ought by sheer inches to overwhelm us with embarrassment. She doesn't. Neo-Gypsy or not, this is a complex human being, still mischievously fresh and alive after solemn burial by the highbrows. The plum-red – prune sauvage – of the dress and cerement-yellow of the spotted background curtain, which is its foil, have never before been rendered full justice in reproduction. The hands are exquisite; the mouth a triumphant vehicle for mirth, by no means owing all to Hals. We have here, from John, not a mother of two of his sons, ²⁰ but an eternally enticing mistress. Dorelia had played him up a good deal before and after Ida's death, and now he makes good-humoured capital out of her infidelities:

Du kannst nicht treu sein, Nein, nein, das kannst du nicht!

- to the rhythm, it could very well be, of a German band blaring away outside his most recent studio in Church Street (now Old Church Street), Chelsea.

Having an anchorage in London did not prevent him from indulging his wanderlust. In the summer of 1908 there had been trips to Rouen, Cherbourg and Dielette with Dorelia and the children.21 By the spring of 1909 he was ready to take to the road again, having incarcerated himself in his studio long enough to paint the flamboyant portrait of William Nicholson (Pl. 48),22 and he began by bringing up the caravan from its last resting-place (Dartmoor) to Wantage, and so by equine forcedmarches to Effingham, where the horse collapsed between the traces. In April, a further van was acquired, along with a light cart and a relay of stouter-hearted animals under care of a groom. The family (nine strong, including Dorelia's sister Edie) were thus transported, a home-made tent supplementing their sleeping-quarters, from Effingham to Cambridge. Here the artist stopped off to paint the Principal of Newnham College, Miss Jane Harrison, who, like Mme Récamier, adopted a reclining pose. The cortège then made for Norwich, whence John himself left for the north, to produce, under some stress and strain, the gigantic picture of Chaloner ('Silky') Dowdall – attended by an even more commanding flunkey - as Lord Mayor of Liverpool. This (Pl. 49), together with his famous 'Mme Suggia' (Pl. 20), represents John's most serious effort to come to grips with grand salon portraiture. One regrets that the attempt, finely dignified yet witty, should not have met with Merseyside's approval, though no doubt it is well enough appreciated in its final home in Australia at the National Gallery of Victoria, Melbourne.

The caravan-jaunt, though nostalgically recorded in a number of amusing snapshots, ²³ proved as dismal as the weather. The groom neglected his job. The horses (when they remained on their feet at all) made wretched progress. John returned to London quite disenchanted with this method of transport. But, immured once more in Church Street, he continued to gasp for air. To his aid hurried a

²⁰ Romilly was born in 1906.

²¹ It should be noted that (to begin with!) Dorelia had an itch for the open road quite as imperious as Augustus'. See, in particular, M.H., pp. 272–3.

²²One of the present collaborators must confess that he has never liked the Fitzwilliam's 'William Nicholson'. Nicholson (1872–1949) won deserved admiration as a designer and still-life painter, but his whimsical personality was not really strong enough to stand up to such *magnifico* treatment.

²³The photographer was Charles Slade, whose brother Loben married Dorelia's sister Jessie.

new admirer, John Quinn,²⁴ conjuring up with the magic wand of wealth gayer modes of travel in climes sunnier than East Anglia. On his side, Quinn promised himself a great deal of fun. Alas, his humourlessness was monumental. These, however, were the early days of the partnership. 'He's a treasure,' Augustus informed Dorelia, in the late summer of 1909. 'He's offered me £250 a year for life and I can send him what I like.'²⁵

Though no such contract was ever formally drawn up between them, Quinn made it possible for John to visit Italy in mid-January 1910 and remain abroad for nine months, the last six of them spent with Dorelia and a sampling of sons in Provence. Often he departed by himself for a few days' parleying and junketing with a chieftain of the Coppersmith Gypsies and members of the Demeter family: as a result of which he was able to furnish the *Journal of the Gypsy Lore Society* with an unusually detailed vocabulary, supported by transcriptions of songs and tales. ²⁶ Earlier, renewing acquaintance with the Italian fifteenth-century masters at first hand, he had delighted in their 'primitivism', and fallen avidly upon works by Piero della Francesca, Ghirlandaio and Botticelli. ²⁷ But he lacked patience for sightseeing and picture-galleries soon damped his spirits. On the train from France, furthermore, he had observed a tiny inland sea glittering invitingly in the sun. It was the Etang de Berre, between the hills of Estaque and the Mediterranean. When he began to tire of Italy, he remembered the sense of excitement with which this stretch of water had filled him.

In March, accordingly, having picked up Dorelia, Pyramus, Romilly, Edwin and a friend, Helen Maitland, ²⁸ at Arles, he conducted them by the route he himself had taken earlier to the charming little town of Martigues, a fishing-port on this same Etang de Berre, where Dorelia (in a white cowboy hat or Leghorn straw) with or without the children would be 'snapped' on celluloid and panel while bathing in the mere or sunning herself on the steps of their house (retained for many years), the Villa Ste Anne. ²⁹ 'What I have been doing here', John wrote to Quinn, after five months in Martigues, 'is rapid sketching in paint. ³⁰ In November 1910, fifty – no less – of these oil sketches, under the title of 'Provençal Studies', were exhibited, together with a splendid group of drawings, at the Chenil Gallery in London, whither the trek back had been made late in September.

It would be difficult, if not impossible, to account for each and every one of these fifty little paintings, some on canvas but the most characteristic on panel. Quinn's own enormous holding has been scattered to the four winds. Since Percy Moore Turner,³¹ on this side of the Atlantic, had a great deal to do with their disposal, many found their way into British private and public collections. Others remained in America, or were carried across the border into Canada.³²

The exact dating of John's work is rarely easy, and the painting of his family in an outdoor setting continued, of course, after 1910, from models who had altered little. Occasionally, the hard facts are provable, when a date follows the signature, or a fancy title, that of Mrs Wilkins' 'Notre Dame de Martigues', say, has survived. There are sketches near the Villa Ste Anne (Pl. 10). But it is often difficult to distinguish between Martigues and Normandy (Pl. 41), and to know in which pool or

²⁴ (1870–1924) lawyer and collector of books and works of art. See B. L. Reid, *The Man from New York: John Quinn and his Friends* (New York, Oxford University Press, 1968).

²⁵ M.H., p. 319.

²⁶ Journal of the Gipsy Lore Society, New Series, Vol. V, July 1910–April 1911, pp. 217–35.

²⁷The clearest echo of his hours in the galleries must be the rhapsodic portraits of Pyramus, already referred to (Pl. 12), and Caspar in a beret (Pl. 50).

²⁸ Dorelia's close friend, that is, who had met the John family on Hampstead Heath. Helen Maitland married a man well known to Augustus, Boris Anrep, the Russian mosaicist; after the marriage broke up she lived with Roger Fry.

²⁹ There is a contemporary series of snapshots in the family album.

³⁰ Letter of 25th August 1910. M.H., p. 348.

³¹ Proprietor of The Independent Gallery, in London.

³² Entering, for example, the Vincent Massey collection.

mere the children paddle under the eye of the lady in the Leghorn hat. Some, however, fit effortlessly into the first Martigues epoch, evoked for us by Romilly John's book.³³ The most beautiful of these gay productions, and as spontaneous as any, we believe to be a picture in the possession of Mr Harris, a quick sketch of Dorelia and the children, known quite simply once as 'Provençal Study' (Pl. 11). Typically, it is on panel, either sized or (as Clifford Hall suggested) lightly glass-papered and oiled, of a type John carried with him in a slotted box on his travels. The artist drew on the wood in pencil, often taking up the pencil again later to define the form over a thin skin of pigment. The jewel-like effect of this little work, its primitiveness, the painterly relation of sitters to an outdoor background: here were elements unusual in a production of the English School before the end of the first decade of the twentieth century.

We can afford to be so specific about the *terminus ante quem*. It was in November 1910, and during the three months bringing us up to January 1911, that the full impact of modern movements in art across the Channel made itself felt in Britain. The importance of 'Manet and the Post-Impressionists', an exhibition organized by Fry,³⁴ is now very generally understood. Not merely the uninstructed public, but artists and art critics, too, reacted in the strongest way to what was set before them at the Grafton Galleries. Nothing has damaged John's reputation so much as his comment on this first introduction of works by Cézanne, Van Gogh, Gauguin and Picasso to Londoners. It was, he told Eric Gill, in words reported back to Will Rothenstein, a 'bloody show'.³⁵ A moment's thought, however, must correct the false impression that John disliked the artists we have just named (as well as others less crucial to the immediate effect of the exhibition). For these men he had already expressed a deep personal admiration.³⁶ What offended him was the hullabaloo. He had not seen the show when he expressed himself thus irascibly. Later, he went twice, declaring himself on the second occasion much impressed. The reason for his enthusiasm was that a fine new batch of Van Goghs had arrived during the interval. He found the Gauguin reinforcements a delight, too. As for Cézanne, 'he was a splendid fellow, one of the greatest'.³⁷

These later tributes, unfortunately, are not as well known as the first explosion of ill-temper. One has been led to think of Roger Fry as the grand cosmopolitan and John as the Little Englander. Fry organized a splendid exhibition of all the French artists we now admire most, and John turned his back on it: thus, greatly to the English painter's discredit, the events of 1910–11 have been arbitrarily interpreted. The truth could not be more different. John had as intimate an understanding of the contemporary French situation as Fry and the Bells³⁸ in Bloomsbury. Pictures which astonished tyros like Gilman,³⁹ sitting at the feet of Sickert and Lucien Pissarro, just across the Tottenham Court Road, were more familiar to John than the creaking signboard of The Cooper's Arms. How nearly his exhibition at the Chenil Gallery approached the Fry show in its revolutionary character may be judged by reviews of the time, reviews whose significance we can only now begin to appreciate.

To the critics, Augustus Edwin John seemed more wilfully eccentric than the 'Frenchmen at the

³³ Romilly John, who is also a poet, excels, in the opening chapter of *The Seventh Child* (1932), in conveying the brilliant colours of Provence.

³⁴ Roger Eliot Fry (1866–1934). John admired his ideas, while deploring the woodenness of his art.

³⁵ Sir William Rothenstein, Men and Memories, Vol. II, p. 213.

³⁶ The only important French modern whom John then really disliked, Matisse, had not been included in Fry's first Grafton exhibition.

³⁷ Letter to Quinn, 11th January 1911. See M.H., p. 362.

³⁸ Arthur Clive Howard Bell (1881–1964) married, in 1907, Vanessa Stephen (1879–1961). The one, in his criticism, the other, in her pictures, paid witty and graceful tribute to the natural superiority of 'la belle peinture'.

³⁹ Harold Gilman (1876–1919), though the most promising of our younger artists, would have been introduced by his mentors to vintage Impressionism only.

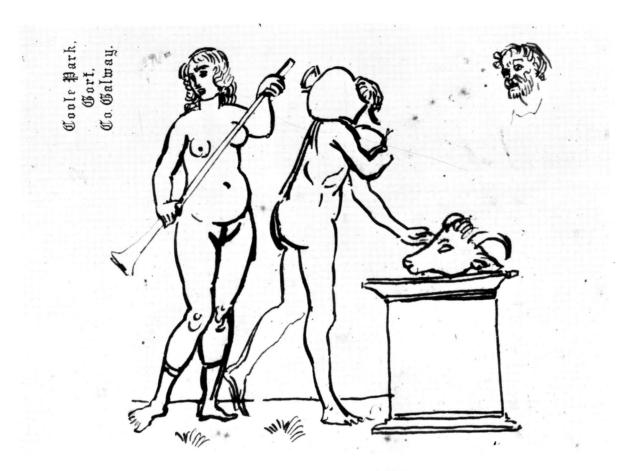

vi A Classical Subject, ? 1915

Grafton'. In *The Times*, one read of the Chenil show: 'What does it all mean? Is there really a wide-spread demand for these queer, clever, forcible, but ugly and uncanny notes of form and dashes of colour? . . . for our part we see neither nature nor art in many of these strangely-formed heads, these long and too rapidly tapering necks, and these blobs of heavy paint that sometimes do duty for eyes.'40 'At his worst', another critic noted, 'he can outdo Gauguin . . . uncouth and grotesque . . . It is unfortunate that Mr John should go on filling public exhibitions with these inchoate studies, instead of manfully bracing to produce some complete piece of work.'41

Thus were the exquisite 'Provençal Studies' received in their own day: that is, with the same caterwaul of horror which greeted the exactly contemporary showing of 'Manet and the Post-Impressionists'.

In the following year, John risked another misconstruction of intent by off-handedly turning down Clive Bell's invitation to contribute to the second Post-Impressionist exhibition, which was to include, besides Matisse and others, living British painters. No particular clash of principle detached John from this enterprise: his own territory had easily absorbed the pre-Cubist Picasso; it could be

⁴⁰ The Times, 5th December 1910.

⁴¹ The Queen, 10th December 1910.

3

The decline, to begin with, was scarcely perceptible. Spared the restrictions of military service, John could profit from what freedom of movement remained, and in the autumn of 1915 crossed to Ireland. Once again he had been commissioned by Lady Gregory to paint a portrait at Coole Park: this time, of George Bernard Shaw. The three studies that resulted, and we reproduce the best (Pl. 56), have an undeniable vigour – but they ring a knell. A boldly accelerated 'drawing with the brush' has succeeded the Ingres-like facture of the Cerutti portrait and the solidity of 'The Smiling Woman'. From now on, and in the same broad, bright, fatally breezy manner, John would become (except in rare instances) almost as banal a recorder of the wealthy and celebrated as Orpen himself. If a buccaneering touch was often added, this rarely upset his clients. We applaud him, of course, for refusing to compete with the more submissive portrait-painters of the day; but there is irony in the fact that, war having permitted a new freedom of manners, John became as petted for his crustiness as they for their flattery.

No sirens yet sang from Belgravia, however. Eaton Square withheld its custom. And for Sampson's pupil the gayest mansions were still green ones. From 1911 onwards, there had been a baffling 'Lyric Fantasy' (Pl. 16) on his hands, its background a horse-and-trap journey from Alderney Manor. 'Lyric Fantasy' was the first and last large-scale composition of John's that promised real success. The Pitmans,¹ after it came into their possession, tactfully turned aside all offers to 'finish' – and so, predictably, to ruin – the picture, which had been undertaken originally as a mural for the house of Sir Hugh Lane² at a time when several very large canvases or cartoons, 'Forza e Amore', 'The Mumpers' (already referred to) and 'The Flute of Pan', were in process of realization,³ and when, even while grinding his teeth over 'Lyric Fantasy', John could propose a companion-piece of similar dimensions.⁴

This last proved a mirage. The 'Fantasy' itself was abandoned after Lane's death in the *Lusitania* disaster of 1915. For many years it glowed with the warmth of a fine tapestry out of the shadows of Mrs Pitman's drawing-room at Odstock. In 1972 it appeared in the Tate, to which she had bequeathed it. The picture stood up to public gaze with dignity, preserving as it does all that was best in John, in particular his beguiling elegance and the charm inseparable from any early work inspired by Ida, Dorelia and the two broods of children. Unlike most other trial flights on the same scale, 'Lyric Fantasy' is *conceived in colour*, and nowhere more expressively than in the passage dovetailing the

¹The late Hugo Pitman and his wife Reine, friends and generous patrons of the artist.

² Sir Hugh Percy Lane (1875–1915), art patron and Director of the National Gallery of Ireland.

³ 'Forza e Amore' appeared at the New English Art Club's winter exhibition in 1911; 'The Mumpers' exactly a year later. In November 1912 he was engaged on an 'immense drawing of the Caucasian Gypsies'. Again at the New English, in the winter of 1913, John showed a large cartoon, 'The Flute of Pan'.

⁴Letter of 24th June 1914: 'As for Lane, I have told him I will do him another design which will harmonize with the big one I am doing for him now.' See M.H., Vol. II, Ch. 1.

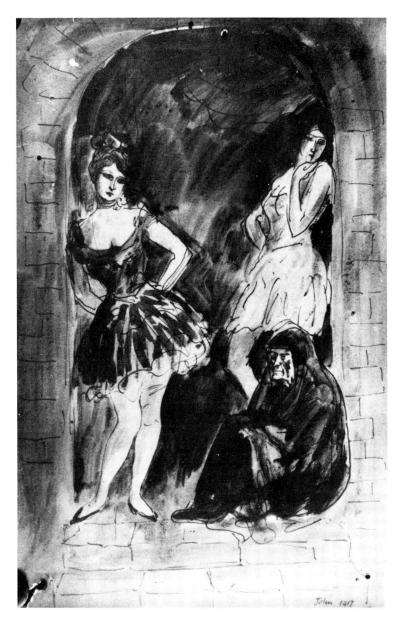

vii Entrance to a Brothel, 1917

scarlet tunic of the young drummer to the blue-green water of the clay-workings.⁵

The most ambitious of all John's mural compositions, the 'Galway' triptych (Pl. 57), belongs to the same year as the Shaw portraits. Leaving Coole, the artist fell in with Francis Macnamara, hereditary squire of Ennistymon.⁶ Together, they made the steamer-trip from Aran to Galway city, 'clustered above the water in a pattern of grey and white'. Before examining the vast canvases in the Tate's Acton warehouse, one should read the brief account in words John gives of the western capital. It well conveys how much the place and its fisherfolk meant to him artistically. An impression is produced, too, of plunging pavements as well as of plunging seas; of endless glasses of the 'hard stuff' in

⁵ Mr Romilly John has thus identified the mysterious 'blue lake'.

⁶ Francis Macnamara, born in 1885 or 1886, died in 1946.

Flaherty's bar on the New Dock. John's long-suffering liver was obviously under duress again: the temptation would be to try it too hard.

Art, however, being seldom strictly autobiographical, 'Galway' now appears the soberest of paintings. Reading from left to right (the three sections, coupled up, would amount to more than forty feet of canvas, measured horizontally), we begin with an al fresco banquet to which, in a trial sketch, the title 'Bank Holiday' has been appended.8 The central panel, the best known and the one reproduced here, shows a highly stylized group of shawled women with their children. In the right-hand, concluding section, a dozen men in billicocks and braces converse together. Even in its over-simplistic centre-piece, 'Galway' is a work of real bone and brawn; though whether John could have taken it much beyond its present semi-monochromatic, sketched-in state may be doubted. Closely connected with the Tate triptych is a similar subject owned by Gwen Lady Melchett (Pl. 17). This is lighter and gayer and constitutes perhaps the most successful of John's fragmentary recollections of his 1915 visit to Ireland. If the observed and invented elements do not always work in well together, it has to be remembered that an artist's opportunities were severely restricted in wartime Galway.9

Though his portraits of Lloyd George and Admiral Fisher¹⁰ might have been regarded as contributions to the war effort, John dearly longed to reach France. He applied for a temporary commission as a war-artist early in 1916, but had to learn patience. A year and more passed before Lord Beaverbrook was able to get him gazetted Major with the Canadians. Writing from Corps Headquarters, near Arras, shortly afterwards, John saw his task as 'immense and magnificent'.¹¹ But when, in the spring of 1918, this brief episode ended, the results fell short, in quality, if not in quantity. He had painted a number of portraits of soldiers and had accumulated a long series of studies for a Canadian War Memorial picture on the scale of 'Galway' which was not, however, continued beyond the stages of charcoal cartoon and oil sketch.¹² Had he been able to adapt to this enormous frieze the fine, low-keyed palette which characterizes 'Fraternity' (Pl. 59), the result might have been a triumph.

The war itself did little, its aftermath more, to alter the tenor of John's life. In 1919, besides painting official portraits at the Peace Conference in Paris, 13 he visited Deauville, meeting there the duchesse de Guiche and the duchesse de Gramont: 'You see what elevated company I'm in,' he told Gwen. 14 But if two seem an overplus of duchesses, this was, after all, the age of artists like de László who kept company with half the Almanac de Gotha. And Deauville soon palled. John's daughter, Vivien, 15 accompanied him to many grand houses and confirms for us that his social digestion was a delicate one, boredom always breaking in. Contemplation of heavily mascaraed marchesas (Pl. 18), like consumption of the hard stuff (though more and more of that was required), only momentarily rescued the artist from his fits of black despair. He knew – if the general public did not – that his work was going downhill; that, through his continual burning of the candle at both ends he had already contracted what, abusing musicians' terminology, we might call wrist-flutter. Yet, still adding here and there to his

⁷ Chiaroscuro, pp. 92–3. The account of Aran characteristically follows that of Galway, a reversal of the historical sequence.

⁸ Cf. Anthony Bertram, Augustus John (1923), Pl. 31.

⁹ Letter to Dorelia, autumn 1915, from Galway: 'Sketching in the harbour is strictly forbidden so that is another drawback and a big one'. M.H., Vol. II, Ch. 2.

¹⁰ Painted in April 1915.

¹¹ Sir William Rothenstein, Men and Memories, Vol. II, p. 311.

¹² The cartoon has always been described as for a 'Canadian War Memorial', whereas the small canvas sketch, identical in composition (Pl. 60) and now owned by Beaverbrook Foundations, is called 'At Liévin Castle'.

¹³ E.g., of Hughes, Massey, Borden, Cecil, Cunliffe, Summers, Goode. The work continued into 1920.

¹⁴ M.H., Vol. II, Ch. 2.

¹⁵ Born in 1915, Vivien is the younger of Dorelia's two daughters; her elder sister Poppet was born in 1912.

family, he needed more money. He needed it, in any case, to underwrite a lordly carelessness and generosity, to maintain studios and a home in England and a house abroad. His three trips to America in the 1920s were cynically undertaken to rake in the dollars; yet, when it came to the point, he would often desert his Wideners and Fullers and Mellons for the humbler pleasures of Harlem. At the beginning of the decade he let his name go forward for election to the Royal Academy.

As an Associate, therefore, he could be sure, in 1923, of getting his huge portrait of Madame Suggia (Pl. 20) into the Burlington House shop-window. The reputation which had sagged since 'The Smiling Woman' of 1908 suddenly revived. Here was a challenge to which John rose magnificently. The celebrated cellist is herself a witness to the time and care the artist lavished on this work. ¹⁶ She posed for two hours consecutively, some days both during the morning and afternoon, and work on the picture continued over a period of three years. A nearly square canvas has been selected to accommodate Suggia's expansive pose and the cascade of skirt flowing down into the lower right corner as she rides her way through an austerely splendid suite of Bach. It is to be supposed, however, judging by the number of alterations involved, that the artist was more often sweating with anxiety than revelling in the grand C Minor. The dress, occupying about a quarter of the picture-area, went through a gold, then a white, then a red (and final) stage. The arms were painted in and out half-adozen times. Physically and nervously extravagant as these shifts may seem, 'Mme Suggia' must be accounted the last late masterpiece of John's professional career.

Another portrait belonging to 1923 is that of Thomas Hardy (Pl. 66), now in the Fitzwilliam. Lightweight after the Suggia, it offers an agreeably crisp and clear impression of a man John genuinely admired. This is a convenient place in which to speak of the 'English Men of Letters' series in the artist's *oeuvre*. Since the pen is demonstrably mightier than the brush, there has always existed a love-hate relationship between practitioners of the two arts. But in *Chiaroscuro* and *Finishing Touches*, one must admit, literary reputations are disposed of with exceptional severity and we read with surprise the stinging comments on writers who were also John's close friends. Can it be that the author nursed some secret ambitions in the same field, making him doubly jealous? Certainly, a fine, Romantic correspondent earlier on (see the brilliant letters first published in *Men and Memories*), he continued to pursue the *mot juste* in his 'Fragments of Autobiography', over which much midnight oil was burned.¹⁷ In his paintings, this carping spirit is absent or concealed, however. During the years from 1917, he did handsomely by Arthur Symons, Ronald Firbank and W. H. Davies (Pls. 58, 61, 63). The paintings of T. E. Lawrence are, not surprisingly, somewhat café-style: John portrays here the celebrity rather than the painstaking compiler of the *Seven Pillars of Wisdom*. We have preferred to reproduce one of the National Portrait Gallery's three drawings (Pl. 62).¹⁸

There is some kinship between these portraits of writers and the various studies of Lady Ottoline Morrell, ¹⁹ of which the most memorable, painted about 1919, appears here (Pl. 19). It will be mistaken years hence for a caricature of some haughty and horsy Edwardian aristocrat. In fact, like Goya's Maria Luisa of Parma, John's Ottoline is a straightforward presentation of a splendidly ugly woman broadminded enough to accept the visual truth about herself. Passions having died down, she remains a dear friend; and, again as Goya saw the consort of Charles IV, John sees Ottoline as a

¹⁶ On 8th April 1923 *The Weekly Despatch* published the article: 'Sitting for Augustus John'. Guilhermina Suggia (1888–1950), born in Oporto, in 1914 settled in England. There are at least two charcoal sketches and an earlier and smaller oil painting of the sitter.

¹⁷ See Mr Daniel George's witty and perceptive Introduction to Finishing Touches, particularly p. 11.

¹⁸John continued to portray Lawrence, though (as it seems to us) with diminishing excitement, after he became Aircraftsman Shaw.

¹⁹ Kinship, because of Lady Ottoline's chosen role of literary (and artistic) muse.

Notes on figures in text

i THE PROMENADE, c. 1900

Pastel: from a photograph (original untraced)

The John Estate

Sir William Rothenstein felt that John's early pastels were superior to his paintings, and spoke of the influence of Daumier: though where the Tate's 'Rustic Scene' is concerned, Millet might be nearer the mark. But it was Degas whose successful handling of this medium took away its stigma as the perquisite of maiden aunts. John himself recalled that the great majority of his own pastels were produced shortly after leaving the Slade; say, about 1898–1903.

ii CHURCHYARD SCENE, c. 1901

Black chalk on buff paper, $10\frac{1}{2} \times 14 (26.6 \times 35.6)$, S

Collection: Mrs Valentine Fleming

Miss Amaryllis Fleming

This is extremely difficult to date. If the costume is contemporary with the drawing itself, then it must be early; and John made the greatest number of drawings in black chalk about the turn of the century. On the other hand (and the style would seem to corroborate it), this might be a 'period' reminiscence. Any allusion to deep human feeling, especially grief, is rare in John's work: hence this drawing's particular interest. Mrs Valentine Fleming's title for it was 'A French Funeral'; but some memory going back to childhood days in Tenby could have been utilized.

iii DESESPERANCE D'AMOUR, c. 1902

From a photograph by Mowl and Morrison, Liverpool (original untraced)

Collection: Judge Dowdall The John Estate

It was an article of faith with John that the bourgeoisie is racked by the passions it condemns. Throughout his work appear disapproving elders, male or female, holding up their hands in horror at the lovers who pass them on the primrose path. Here youth, for a change, expresses its contempt for age. In style and composition, as well as fancy, this lost picture resembles another, showing Orpen 'escaping from his relatives', recently with Mr Anthony d'Offay.

iv SPECTATORS IN A PICTURE-GALLERY (?), c. 1912

Pen, brush and black ink: from a photograph (original untraced)

The John Estate

The interest here is the baffling strangeness of the style, more reminiscent of Edvard Munch (1863-1924) than of John who, nevertheless, appends an irreproachable signature.

V THE BRAGGING SOLDIER, 1915

Soft pencil on paper, $9 \times 10\frac{3}{4}$ (22.8 × 32.4)

Signed 'John' bottom right

Miss Amaryllis Fleming

An unpublished and interestingly uncharacteristic drawing, 'The Bragging Soldier' (with its provincial air) belongs almost certainly to the Irish visit of 1915. The men, John explains in his correspondence, were going away 'to fight England's battles', and there was a great wailing on the platforms as the women saw them off. Most of the women, having men in the Army and Navy, received Government pay: 'the consequence is an unusually heavy traffic in stout'. There seem to be no references to such military matters from Wales.

vi A CLASSICAL SUBJECT,? 1915

Pen and blue-black ink on Lady Gregory's grey, embossed writing-paper, $4\frac{7}{16} \times 7$ (11·4 × 17·8)

The John Estate

John paid his first visit to Coole Park in 1907; but the style of the drawing suggests a later date, which could be 1915 (provided the paper was not purloined and put to this use after his return to England). With Keats, one inquires, 'Who are these coming to the sacrifice?' The composition does not seem to have been carried further, and the question remains unanswered. Though he must have been a keen admirer of Ingres, John rarely ventured into the world of classical mythology.

vii ENTRANCE TO A BROTHEL, 1917

Pen-and-ink and wash or watercolour: from a photograph (original untraced)

Signed and dated 'John 1917' bottom right

The John Estate

The theme of prostitute and procuress may have come to John by way of the Venetian School and Caravaggio and the Caravaggesque. In pen-and-ink, it harks back to Guys. Or is it a memory of old Marseille? The seated hag crops up perennially in John's work, expressing her displeasure wherever the joys of youth are celebrated. In December 1917 the artist arrived in France for his brief tour of duty as war artist, but the sketch hardly suggests Canadian Corps H.Q.

viii PLAISIRS ET MISERES DES COURTISANES. ? c. 1920

Crayon, pen and black ink, $14\frac{5}{8} \times 10\frac{1}{2}$ (37·1×26·7)

The John Estate

We have chosen a title which would equally suit a multitude of sketches thrown off by John over the years. If the atmosphere is Balzacien, this would be in keeping with the literary taste of the artist and his friends about the close of the nineteenth century. Charles Conder (1868–1909) produced a series of lithographic illustrations to the *Comédie humaine*. For a portrait of Alick Schepeler John chose the title 'Séraphita', one of Balzac's stories from the *Etudes philosophiques*. The drawing is a flight of fancy offering no blandishments. But this deliberate clumsiness matched a recurrent mood in John. Here, we believe, he returns quite late to the old topic.

Augustus John : Chronology

1878	4th January, born at Tenby, Pembrokeshire, Wales.	1902	6th January, David born. Autumn, meets Dorothy McNeill in London.
1884	August, mother dies. Family move from Haverfordwest to Tenby.	1903	Elected to N.E.A.C. March, Carfax Gallery. Paintings
1894–8	Slade School of Fine Art, London.		(3), Pastels (8), Drawings (21) and Etchings (13) by Augustus E. John.
1897	Bathing accident.		Paintings (3) by Gwen John. 22nd March, Caspar born.
1898	'Moses and the Brazen Serpent' wins the Summer Composition Prize. Visits Holland with Ambrose McEvoy.		August, Gwen and Dorelia's 'walk to Rome', via Toulouse. Augustus and Ida move to Elm House, Matching Green, Essex.
1899	First one-man show at Carfax Gallery. Makes £30 and goes to Vattetot-sur-mer with William Rothenstein, William Orpen,	1903–7	Involved with Orpen and Knewstub in the Chelsea Art School, Rossetti Studios.
	Charles Conder. Meets Oscar Wilde in Paris. Begins exhibiting at New English Art Club.	1904	Gwen and Dorelia arrive in Paris. Dorelia elopes to Bruges. August, Dorelia returns and lives at Elm House.
1900	Goes to Swanage with Conder. 'Walpurgis Night'. Visits Le Puy-en-Velay with the Rothensteins and Michel Salaman.		Augustus elected to membership of the Society of Twelve. 23rd October, Ida's Robin born.
	Painted by Orpen.	1905	April–May, on Dartmoor. Dorelia's Pyramus born.
1901	12th January, marries Ida Nettleship. Moves into 18 Fitzroy Street, London.		September, emigration to rue Monsieur-le-Prince, Paris. November, Chenil Gallery.
1901–2	Art instructor at Liverpool. Meets John Sampson and the Dowdalls. Etchings.		Drawings by Aug. E. John (42) and William Orpen (22). 27th November, Ida's Edwin born.

1906	January, move to 77 rue Dareau, Paris. May, Chenil Gallery. Eighty-Two Etchings. Alick Schepeler. August, at Ste-Honorine-des-Pertes with Wyndham Lewis. Dorelia's Romilly born. November, Dorelia detaches herself and moves to 48 rue du Château.	1911	Other Works (35 drawings). Begins working with J. D. Innes. Elected to the Camden Town Group. May, rents cottage with Innes in North Wales. July, paints Kuno Meyer in Liverpool.
1907	February, Augustus and Ida move to 3 Cour-de-Rohan. 9th March, Ida's Henry born.		August, moves to Alderney Manor. September, in France with Quinn. October, in Wales. December, Chenil Gallery. Paintings, Drawings and Etchings.
	14th March, Ida dies. Summer, at Equihen with Dorelia. September, visits Lady Gregory at Coole, Ireland. Paints W. B. Yeats. Moves to 8 Fitzroy Street, London. November, Carfax Gallery. Eighty-one Drawings.	1912	March, Pyramus dies. Poppet is born. Summer, West Coast of Ireland with Francis Macnamara and Oliver St John Gogarty. September, stays at Chirk Castle with the Howard de Waldens.
1908	Gets to know Lady Ottoline Morrell. Starts off for Spain, via Paris. July–September, at Dielette with Dorelia and children. Visited by Mrs Nettleship. Autumn, moves into 153 Church Street with Dorelia and families.	1913	January, in South of France with Innes. February, Armory Show, New York (23 paintings, 14 drawings). Spring, Madam Strindberg's Cabaret Club opens. July, North Wales with Holbrooke and Sime.
1909	January, paints William Nicholson. Takes studio at 181a King's Road. July, caravans to Cambridge. Paints Jane Harrison. August, paints His Worship the		August, visits Modigliani in Paris. September, North Wales. November, Goupil Gallery. Fifteen Panels.
	Lord Mayor of Liverpool, and Smith. Meets John Quinn in London. September, agrees to decorate Hugh Lane's house.	1914	February, elected President of the National Portrait Society. In Cornwall with Laura Knight. April, Crab Tree Club opens. May, Cardiganshire.
1910	January–September, travels, at Quinn's expense, to Italy and Provence. Visits Frank Harris at Nice. April, Villa Ste Anne, Martigues. November–December, Chenil Gallery. Provençal Studies (48) and		Gives up studio at 181a King's Road, moves into 28 Mallord Street. June, one week in Boulogne. August, Eilean Shona, Acharcle, Argyleshire. Last visits to Innes at Brighton and Swanley in Kent before his death. October–November, drilling with

	Wadsworth in the courtyard of the		Kunsthaus, Zürich.
	Royal Academy. December, sees Gwen John in Paris. Fails to persuade her to return to England.	1919	February–May, in Paris as official war artist. Paints Marchesa Casati and duchesse de Gramont.
1915	March, Vivien born. June, at Coole. Paints three portraits of Bernard Shaw. Hugh Lane sunk in Lusitania. October, Aran Islands and Galway.		First drawing of T. E. Lawrence. March, Chenil Gallery. One hundred and twenty-five etchings. September, at Deauville with Lloyd George.
1916	February, Chenil Gallery. Paintings (21) and Drawings (41). Portrait of Lloyd George. May, Chenil Gallery. Etchings by Augustus E. John. July, goes to Herbert Barker for knee operation. August, rejected for military service. 'Galway' shown at Arts and Crafts Exhibition, Burlington House.	1920	Augustus John by Charles Marriott published by John Lane in the 'Masters of Modern Art' series. Elected Fellow of University College, London. March, Alpine Club. War, Peace Conference and Other Portraits (39 exhibits). April, Sister Carline Hospital. Operation on nose.
1916	Starts experiments in lithography. Bust by Jacob Epstein.		May, Rouen and Dieppe. October, rumpus over Lord Leverhulme's decapitated portrait.
1917	20th March, Monster Matinée at Chelsea Palace Theatre. 27th April, meets Lady Cynthia Asquith.		John retreats to Broadstairs. Campbell Dodgson's <i>Catalogue of Etchings by A. E. John</i> published.
	August, portrait of Oliver St John Gogarty. 9th October, begins portrait of Lady Cynthia Asquith ('Lady in Black').	1921	22nd April, elected Associate of the Royal Academy. Begins painting Mme Suggia. June, portrait of Herbert Barker.
	November–February (1918), Alpine Club. Pictures and Decorations (67 exhibits). December, advances to Aubigny as a Canadian major.	1922	March, the Sculptors' Gallery, New York. Works by Epstein, Gaudier-Brzeska, Innes, Augustus John and Wyndham Lewis from Quinn Collection. (7 Paintings, 7 Drawings).
1918	March, retires from France after knocking out Captain Wright. May, starts Canadian cartoon. 'Fraternity'.		April, Paris. May, arrives in Spain.
	8th–28th August, represented at Englische Moderne Malerei, an exhibition organized by the Contemporary Arts Society at the	1923	March, Alpine Club Gallery. Paintings and Drawings. First showing of 'Mme Suggia'. 28th March–23rd June, America.

1 AN OLD LADY, 1899

Oil on canvas, $26\frac{3}{4} \times 22 \ (68 \times 56)$

Exhibited Arts Council, 1945–6 (No. 91)

The Tate Gallery

When Sir John Rothenstein discovered this painting at the Leger Galleries in 1941 and bought it for the Tate, he was informed by the artist that the sitter had given him his very first commission in portraiture. The old lady, her name later forgotten, lived in Eaton Terrace. 'The fee was fixed at forty pounds,' John recalled, 'of which half was paid in advance.' But mutual dislike resulted in his abandoning the picture and forgoing the balance. None of this comes through in the work, which is fresh and sympathetic, except that he was unable to finish the right hand. The head is modelled in the yellow-brown-against-darker-brown of Rembrandt: whose influence, however, would not be paramount for much longer.

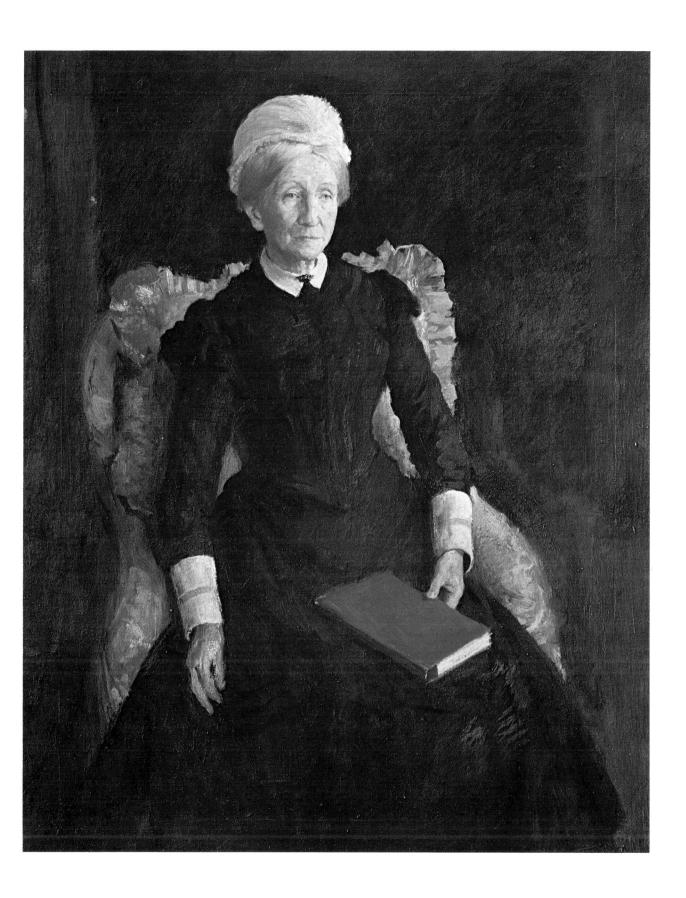

2 IDA, c. 1901–2

Oil on canvas, $24 \times 18 (70 \times 45.5)$

Exhibited Broadway Art Gallery, spring 1962 (No. 5)

Collection: the artist's father, Edwin William John

Mr and Mrs John Gardner

Another painting, showing Ida in an identical dress and having the same provenance, was entitled 'A Sketch near Tenby'. Ida and Augustus married on 12th January 1901, and paid a duty visit to the artist's father later that year and again in 1902. Augustus disliked Tenby. On either occasion he could have cut short his stay, leaving this portrait behind. It remained forgotten till old Mr John's death in 1938, when the attic at 5 Lexden Terrace was cleared out by the housekeeper, a member of whose family sold the picture to the present owner (Augustus having expressly refused to bother himself with such lumber). The wedding-ring rules out, of course, a date earlier than 1901. If Ida's glance conveys a certain apprehension, this would not be extraordinary in one struggling to keep pace with her husband's swift changes of mood even during the initial period of the marriage. The portrait was restored in 1962 and the paint is now very thin.

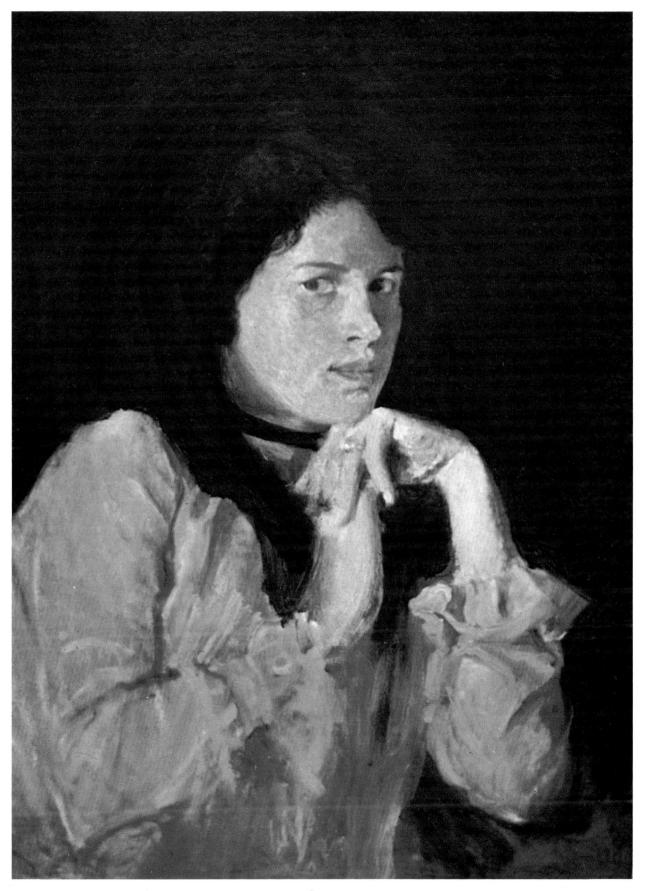

[49]

3 IDA PREGNANT, ? 1901

Oil on canvas, $60 \times 40 (152 \cdot 5 \times 101 \cdot 5)$

Collection: Michel Salaman The National Museum of Wales

Together with that picture of his future wife which, John tells Michel Salaman in February 1900, 'has clothed itself in scarlet', this is one of the very few full-length oil portraits of Ida which have survived. It remained for several decades in the Salaman home, Michel himself having been a contender for Ida's hand, and his brother Clement actually engaged to her. 'Ida pregnant' was not seen by the general public till put on view in the National Museum of Wales in 1972. In spite of the colour, there is a striking dependence upon Hals.

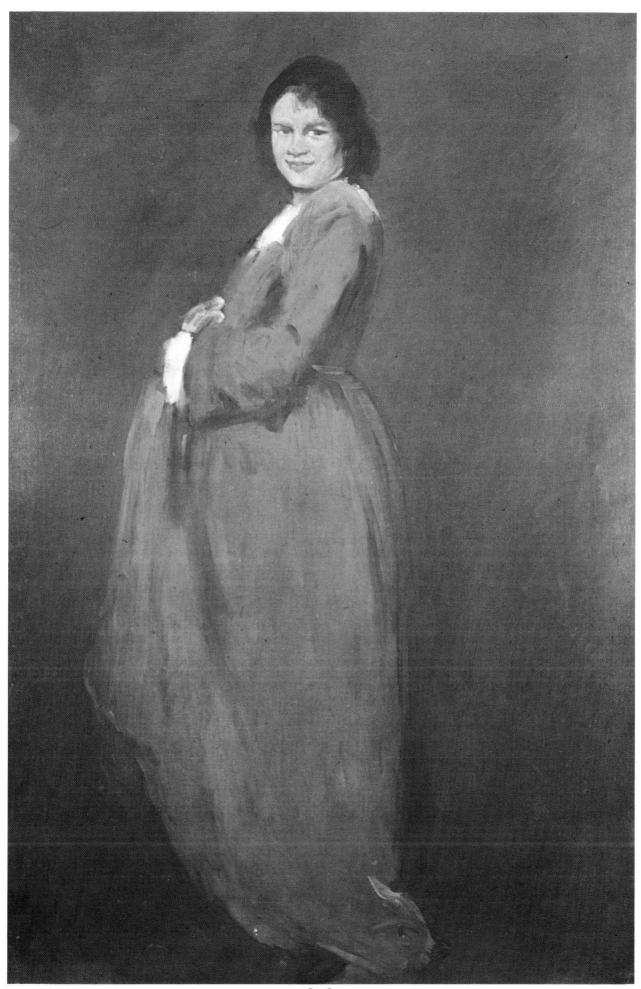

[51]

4 SIGNORINA ESTELLA CERUTTI, 1902

Oil on canvas, $36 \times 28 \ (91.5 \times 71)$

Signed 'Augustus John' on back of canvas

Exhibited N.E.A.C., winter 1902 (No. 63); Temple Newsam, 1946 (No. 3); R.A., 1954 (No. 343)

Collection: Judge William Evans The City Art Gallery, Manchester

The Italian girl whom the artist called 'Esther' Cerutti lived in rooms below the Johns at 18 Fitzroy Street, their earliest London home. Augustus made a number of studies of her in various media. Ida, having a baby—and then babies—to look after, could feel outshone at times by the buxom, well-groomed model: 'for how can one wear grey linen by her silks and laces?' (letter to Alice Rothenstein). But Esther's reign proved transient enough.

This is an extremely important work, by which (as Sir John Rothenstein has pointed out) John's stature can be judged for the first time. Here is Olympian drawing with the brush, supplying marvels of supple, sinuous edge. As to colour, the artist never bettered the peach-like bloom of the lit flesh and the reflections in the shadowed areas. The hands' pose recalls that in a Velázquez Infanta, but the closest parallel of the whole is to be found in Ingres' copies of his 'Duc d'Orléans', one of which is now (but was not then) in the National Gallery. After the Cerutti portrait, John for the most part abandoned such finely adjusted contours. Whether he regretted it or not, he felt obliged to leave the nineteenth century behind.

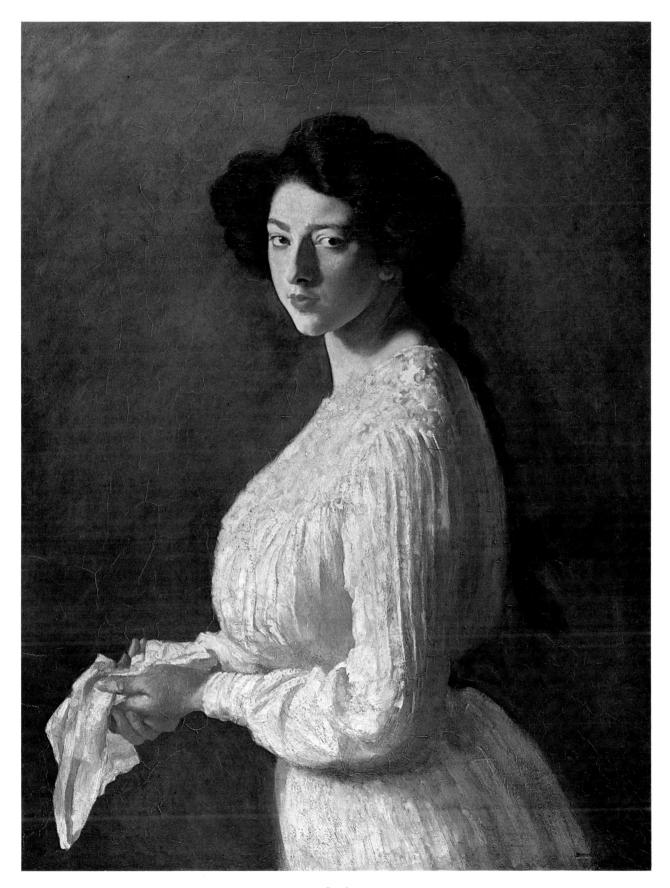

[53]

7 FRENCH FISHER-BOY, 1907

Oil on canvas, $86 \times 35\frac{1}{2}$ (218.5 × 90)

Collection: John Estate Mr and Mrs Stephen Tumim

After Ida's death on 13th March 1907, John's art, as well as his domestic life, took various turnings, first in one direction, then another. 'I should like to work for a few years entirely "out of my head", perhaps for ever,' he wrote in April to Will Rothenstein. Paris distracted him. In the same month he set out to explore the 'top of France', soon discovering Equihen, suitably off the beaten track on the north coast near Condette. The fisher-folk, both men and women, reminded him of a similar community near Haverfordwest in childhood days. The boy he paints on this occasion is very much out of John's head: though an admiration for Gauguin makes itself felt—and, more, for Picasso. We assume that John knew the 'Blue Period' Picassos (he had certainly seen the historically all-important 'Les Demoiselles d'Avignon' in the same studio) before he wrote that letter to Henry Lamb, of 5th August, describing the Spaniard's work as 'wonderful'. He was, as a matter of fact, once again at Equihen in August.

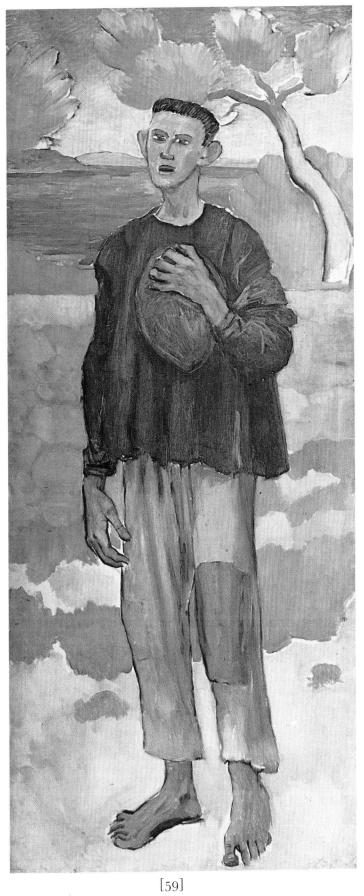

8 W. B. YEATS, 1907

Oil on canvas, $29\frac{1}{2} \times 19\frac{1}{2} (75 \times 49.5)$

Exhibited Birmingham, 1952 (No. 35); R.A., 1954 (No. 345); Sheffield, 1956 (No. 22)

The City Art Gallery, Manchester

Lady Gregory's son Robert suggested that John should undertake the portrait of William Butler Yeats (1865–1939) required as a frontispiece for A. H. Bullen's 1908 edition of the *Collected Works*. It was to be an etching. But, as other artists' have been, John's preliminary sketches were paintings, the one shown here and another in the Tate Gallery, besides additional studies. It is difficult to think of a better realization of the leader of the Celtic Revival in literature, dark and dreamy against a brilliant, emblematic green. John admired the gift of tongues; a writer always drew from him his best work. Yeats, however, complained bitterly to Quinn, particularly of the etching, which made him, he felt, 'a sheer tinker, drunken, unpleasant and disreputable'. Lady Gregory held up her hands in horror, too. Looking now at the Manchester painting, of which the etching is a transcription in reverse, we are astonished at all the fuss. But this was John's universal reputation: everything he touched seemed to his contemporaries to have been deliberately coarsened, if not caricatured.

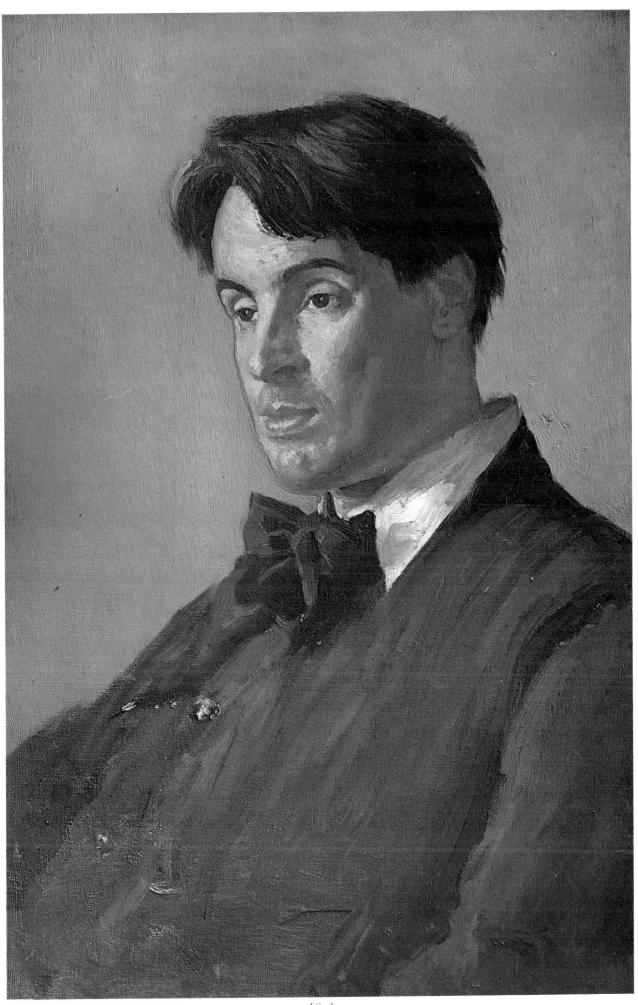

[61]

9 THE SMILING WOMAN, 1909

Oil on canvas, $77 \times 38 (195.5 \times 96.5)$

Exhibited New Gallery, 1909 (No. 181); and in a series of Contemporary Art Society exhibitions in Newcastle, 1912 (No. 158), at the Goupil Gallery, 1913 (No. 21), at 53 Grosvenor Street, and in Belfast, 1914 (No. 13)

Collection: Dr C. Bakker; Contemporary Art Society *The Tate Gallery*

This portrait of Dorelia found its way to the International Society's exhibition, 'Fair Women', at the New Gallery in Regent Street, and made John's name. His first idea had been on the lines of the later 'Lyric Fantasy', of a group of pixie-ish beauties dominated by Euphemia Lamb. Euphemia failed him. A barmaid called Bertha did not come up to scratch. Alick Schepeler faded out. Finally Dorelia, unhappy about this constant change of plans, agreed to sit solo. Roger Fry (in The Burlington Magazine of May 1909) can be forgiven for not recognizing in the model a Miss Dorothy McNeill of respectable urban origins. 'The vitality of this gypsy Gioconda,' he wrote, 'is fierce, disquieting, emphatic': and he was quite right. Between them, John and Dorelia had affected an ethnic change of the most startling order. Fry proved extremely fair in his appraisal of a work by no means up Bloomsbury's street. 'The very swiftness of the handling,' he continues, 'the summary strokes with which the swift play of the features and the defiant poise of the hands are suggested heightens this effect of intense life, just as the large, simple massing of the colours accentuates the dominant rhythm of the design.' And the inevitable sting in the tail was not as deadly as it might have been: 'Yet this intensity has not been obtained without some sacrifice. Even among other modern pictures the work looks bare, for all its dignity: in more weighty company this bareness might become baldness. The very haste which has contributed so much to the spirit of the piece has brought with it an undeniable loss of that shapely and pleasant handling of material which has been an aim, if not the supreme aim, of so many other generations of great artists... Fortunately there are many mansions in the house of Art; and if a remarkable talent chooses one of them we should be content to let him have his place there, even if we think he might be better accommodated elsewhere.' The picture was presented to the Tate in 1917 by the Contemporary Art Society.

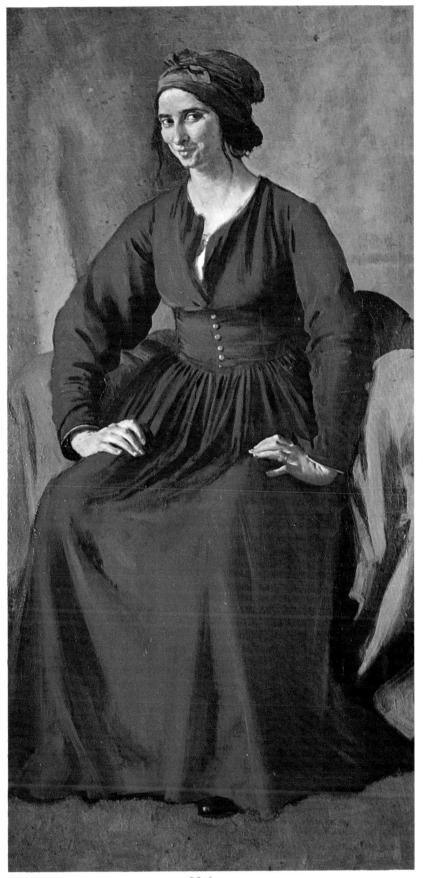

[63]

10 NEAR THE VILLA STE ANNE, 1910

Oil on canvas, $10\frac{3}{4} \times 18\frac{1}{2}$ (27 × 32)

Private Collection

Without doubt, John was never more in his element than in Martigues, first spied from the train as he crossed into Italy during his 1910 travels under Quinn's aegis. By April of that year, the date of the painting of this picture, the family was established at the Villa Ste Anne, with its views of the Etang de Berre, the little town of Martigues and a not so distant Mont Ste-Victoire. The un-English brilliance of sky and inland sea was joyously recorded by John as a background for the velvety grey of the olives and the vividly-dressed Dorelia and assorted children. Painted just before Fry's first Post-Impressionist exhibition, such a study explains John's avant-garde standing, though he gradually thereafter retired into a haughty and self-sufficient isolation.

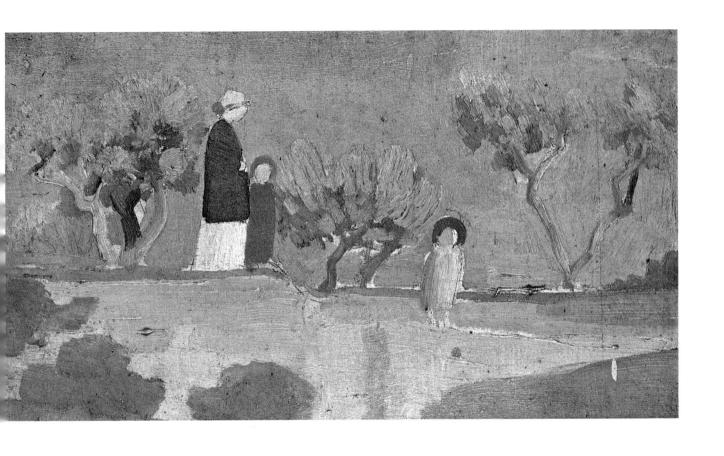

11 DORELIA WITH THREE CHILDREN, 1910

Oil on panel, $9\frac{1}{4} \times 12\frac{3}{4} (23.5 \times 32.5)$

Signed 'John' bottom right

Exhibited R.A., 1954 (No. 211); Liverpool, 1955 (No. 22); King's Lynn, 1959 (No. 25); University of Hull, 1970 (No. 26)

Mr Peter Harris

The picture belongs to the period of John's initial discovery of Martigues during the prolonged stay abroad in 1910. The young boy on the left, one may presume, is David (his entitlement to the 'large hat' is discussed in the note to Pl. 38). The child to the right suggests Pyramus, but either of the little ones could be Romilly, who gives a particularly vivid picture of Martigues in his *The Seventh Child*. What we see here is the fifteen-foot bank looking out on the blue lagoon called the Etang de Berre. Close at hand was the Villa Ste Anne, a house retained by John for family holidays until as late as 1928. 'Wherever my larger half-brothers went,' records Romilly, 'whether up cliffs or down ravines, there I was always to be found, panting in the rear.' To read some accounts of contemporary British painting, one might suppose that it was Gore and Gilman who lightened our native palette and Sickert who first insisted that the model must be observed in a natural context. John's blues and greens and crushed-strawberry pinks qualify the first assumption, while the French and (soon) the Dorset settings with which Dorelia is invariably united lead us to question the second.

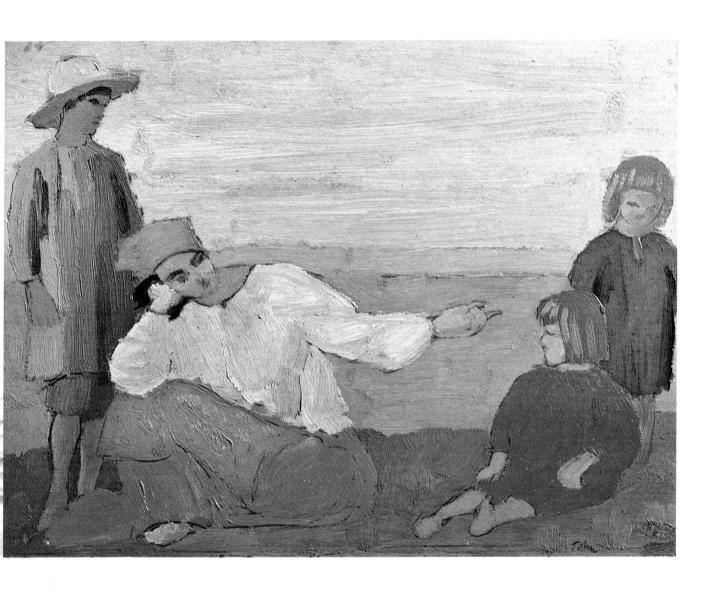

12 PYRAMUS, c. 1910

Oil on panel, $15\frac{1}{4} \times 12\frac{1}{2} (38.5 \times 31.5)$

Exhibited University of Hull, 1970 (No. 20)

Private Collection

Born in 1905, Pyramus was Dorelia's elder son and eldest child, the others being Romilly and the two girls, Poppet and Vivien. John Knewstub, who ran the Chenil Gallery, described Pyramus as the 'most lovable' of all the artist's sons. The corn-coloured hair may seem surprising, but Romilly recalls that, like his half-brothers, both he and his full-brother were fair as young children. If the type of bust-portrait suggests Tuscan work of the late fifteenth century, this is what we might expect: for in 1910, on a first trip to Italy, John was reporting to Quinn, his American patron, how greatly he admired Luca Signorelli. Pyramus had been born in a caravan, and shared to the full his parents' wanderings and his brothers' barefoot existence. He does not seem to have suffered for roughing it; but in his seventh year he fell ill with meningitis. He died in the early summer of 1912.

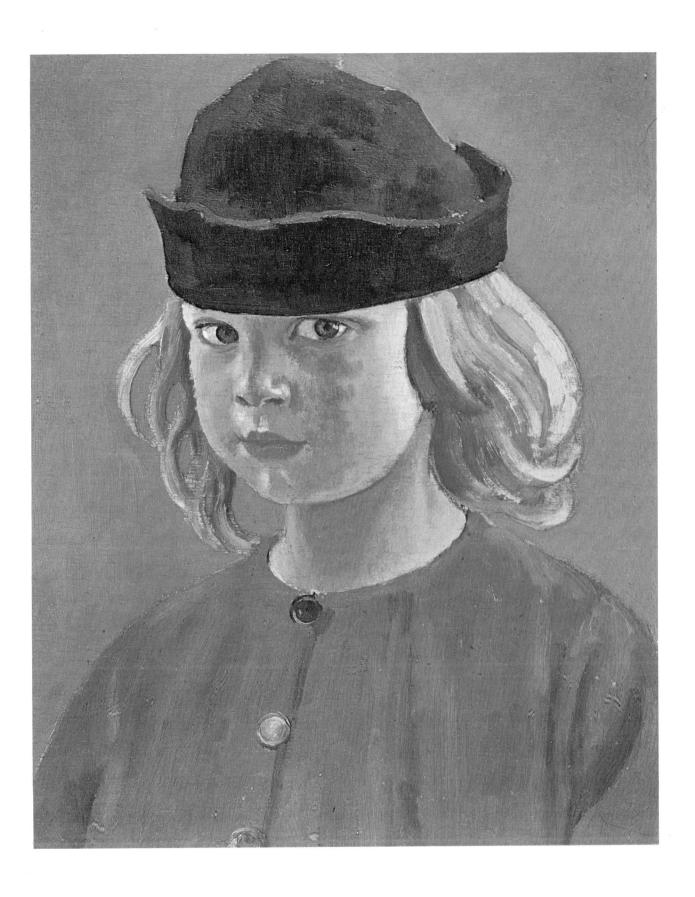

13 LLYN TREWERYN, 1911

Oil on panel, $12\frac{1}{2} \times 16 \ (31.5 \times 40.5)$

Collection: Antonio Gandarillas

The Tate Gallery

John had been searching for an ideal landscape long before he met John Dickson Innes (1887–1914), at the same time employing a flat-colour simplification which, if reminiscent of the younger man's approach, certainly did not derive from it. Yet, suspicious of alliances in general, John found in Innes the perfect companion in wanderings far afield. Both had been brought up in Wales, both felt especially at home among the peaks and tarns of the Welsh highlands. Enjoying Innes' company, John shared a cottage with him near Rhyd-y-fen (Merionethshire) on the slopes of the Migneint during the summer of 1911. They filled panel after panel with views of this district, returning regularly, sometimes with Derwent Lees (1885–1931), in the few years still left to Innes. John's painting of Llyn Treweryn, a diminutive stretch of water sparkling under kaleidoscope mountains and a brilliant blue sky is at the very opposite pole from Innes' savage renderings of Mount Arenig nearby. The picture was on view at the Chenil Gallery under the title of 'The Blue Pool' in 1917.

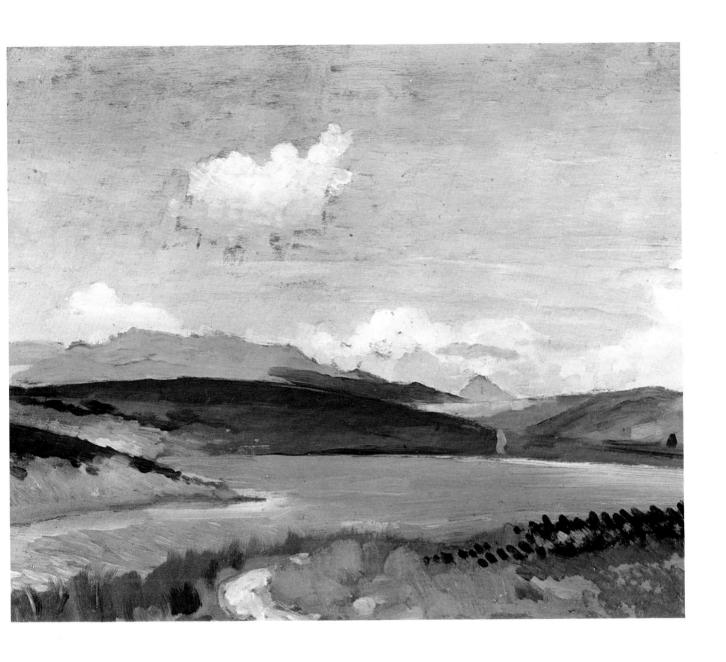

14 ROMILLY, ROBIN AND EDWIN, 1911

Oil on panel, $16 \times 13 \ (40.5 \times 33)$

Signed 'John' top left on the bare wood

Exhibited Temple Newsam, 1946 (No. 21); R.A., 1954 (No. 210); University of Hull (No. 28)

Lady Kleinwort

An old label on the back establishes, no doubt correctly, the identities of the children, together with the date and place: the latter, the county of Dorset. It was in 1911 that the Johns moved from Chelsea to Parkstone, near Poole, to the 'Gothick' bungalow set in its wild garden and romantic heathland. Here Robin would be about seven; Romilly and Edwin, five and six. The sunlight flooding the scene suggests what Romilly long afterwards called the 'glorious summer of our installation'.

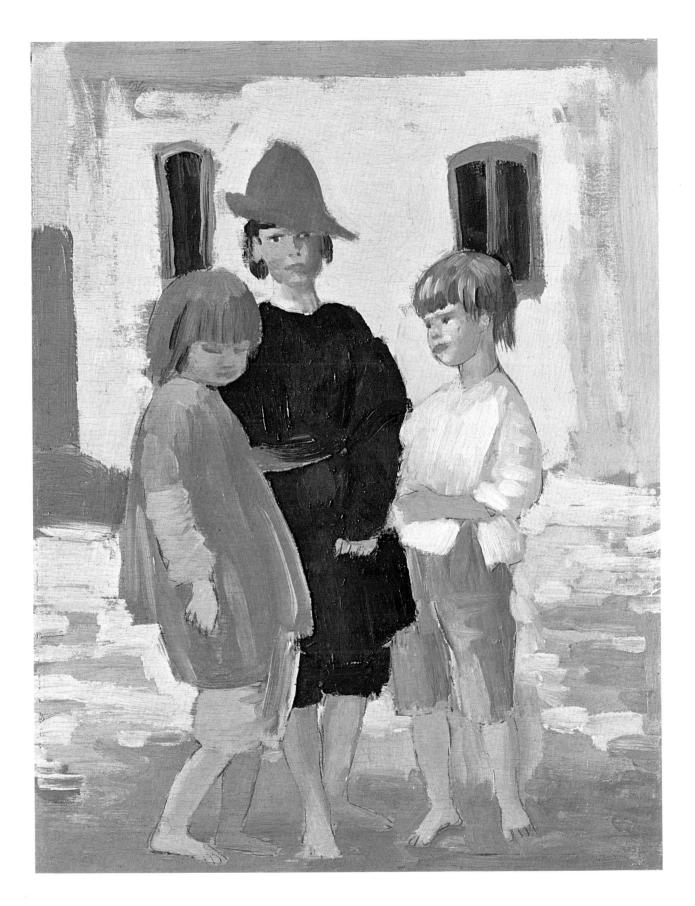

15 THE MUMPER'S CHILD, c. 1912

Oil on panel, $22\frac{1}{2} \times 19 \ (57 \times 48)$

Signed 'John' bottom right

Exhibited R.A., 1954 (No. 366); Liverpool, 1955 (No. 27); King's Lynn, 1959 (No. 33)

Mr Peter Harris

In Henry Lamb's words, Alderney Manor, to which the Johns moved in June 1911, was an 'amazing place – a vast secluded park of prairies, pinewoods, birchwoods, dells and moors' as well as a house where lived the Wimbornes' eccentric tenant with Dorelia and her raggletaggle charges. When the lunch bell sounded, Romilly tells us, and the family trooped back into the house, the grounds filled up with poachers and marauders, a gang of thieves (their progeny trundling piratical soapboxes on wheels), whom the gypsies themselves declined to regard as equals. Inheriting an old English title meaning 'beggars'*, they made themselves at home in John's unfenced territory, establishing their claim to rabbits and firewood, and finally conquering his good opinion. These mumpers, like the artists themselves, were but part of the great consortium of outcasts. The portrait known as 'The Mumper's Child' is splendid in colour, and one of John's finest evocations of the wild earthiness he loved so well.

^{*} Or, in modern times, to use Mr Rupert Croft-Cooke's definition, 'non-gypsy travellers', i.e. tramps.

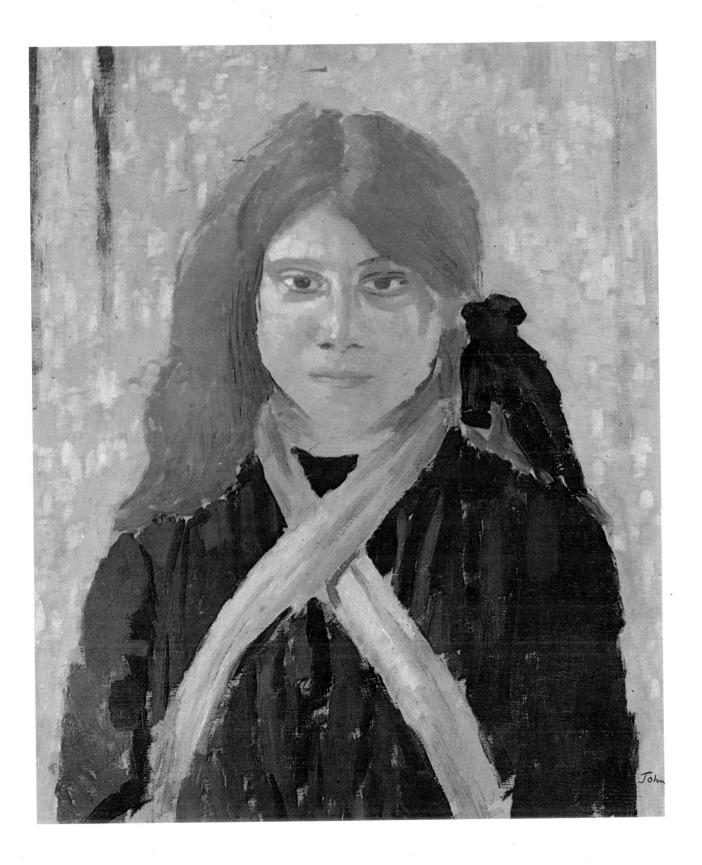

16 LYRIC FANTASY, 1911–1915

Oil on canvas, $92 \times 185 (234 \times 470)$

Exhibited N.G., 1940, 'British Painting since Whistler' (No. 183); R.A., 1954 (No. 37); and – as 'The Blue Lake' – R.A., summer 1962 (No. 124)

Collection: Hugo Pitman; Mrs Reine Pitman The Tate Gallery

In a letter, undated but certainly of 1907, to John Fothergill, the artist wrote: 'I am about to paint a picture which will prove conclusively that the finest decoration can be produced without any direct reference to visual "Nature" – that is it will be as it were a natural growth itself – coming unbidden and self-sufficient like any flower and not at all concerned to imitate other flowers.' 'Lyric Fantasy', though later, is the supreme example among John's works of this large-scale improvisation. The world transferred on to the canvas is an imaginary one; uncomfortably so, since Ida herself (extreme right) reappears like Proserpine from the Underworld to part two quarrelling boys. Seeing the picture again quite recently, Romilly thought these two might be Caspar and himself, just as he might also be portrayed – as a much younger child – in the arms of the unknown woman in the centre. The two women to the left cannot be identified. There is no doubt, of course, that the guitar-player is Dorelia herself. Its unfinished state is a further proof that, the picture having 'taken charge', problems arose which improvisation could not solve. Much as John may have regretted the death of Sir Hugh Lane in the Lusitania disaster, and the end of Lane's Cheyne Walk murals, he seems to have been glad to throw his hand in. 'Lyric Fantasy' remained rolled up in the smaller Fryern Court studio till Hugo Pitman discovered it by chance nearly twenty years later. Though freely interpreted, the setting owes much to Wareham Heath, Dorset, where there are a number of small lakes occupying the site of old claypits. The largest and best known is the Blue Pool, Furzebrook, its colour determined by finely suspended clay particles and enhanced by the surrounding yellow sandhills.

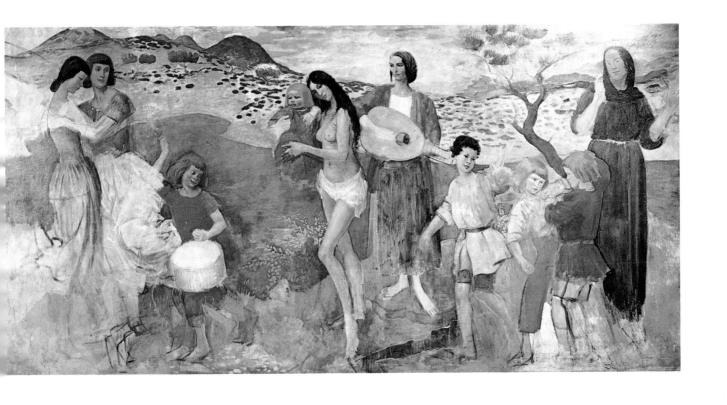

17 GALWAY SUBJECT, 1916

Charcoal and bodycolour on paper laid upon canvas, $105 \times 142 \ (266 \cdot 5 \times 366)$

Exhibited Upper Grosvenor Galleries, 1965 (No. 66)

Gwen Lady Melchett

In addition to these two panels which form a single composition, the present owner acquired a further panel in the same series, its dimensions some ten inches greater both vertically and horizontally. The three panels, in spite of many fine qualities, are evidence of John's regrettable tendency to theatricalize the proletariat. Some pull seems to be exerted back to the noble peasants of Puvis de Chavannes, but these stereotypes are then, in a disconcerting – and artistically distracting – manner, made fun of. The fact is that John was looking for peasants when the peasantry had ceased to exist. 'Their drapery is often very pleasing – one generally sees one good thing a day at least – but the population is greatly spoilt now – 20 years ago it must have been astonishing,' he wrote to Dorelia. The lower orders in Russia, symbolized by a Grigori Rasputin capable of praying, tippling and dancing a komorinskaya to the phonograph at the same time, might have suited him better. But the October Revolution of 1917, if not the Easter Rising of 1916, revealed the essential artificiality of Chelsea-style celebrations of the Simple Life.

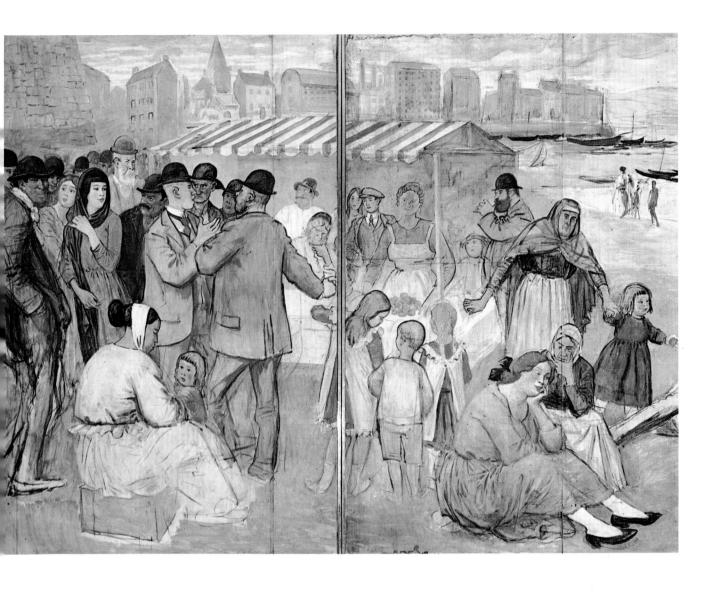

18 THE MARCHESA CASATI, 1919

Oil on canvas, $38 \times 27 (96.5 \times 68.5)$

Exhibited Toledo and Toronto, 1948 (No. 18); Halifax, Nova Scotia, etc., 1972–3 (No. 29)

Collection: Sir Evan Charteris The Art Gallery of Ontario

Still sartorially a Major attached to the Canadians, John was invited to Paris in 1919 to paint pictures commemorating the Peace Conference. This meant a series of portraits, by no means exclusively of ministers and generals. Through a Chelsea friend, Gandarillas, he was able to establish himself in an apartment in the fashionable Avenue Montaigne; during the day he frequented the Hôtel Majestic, where many of the Allied delegates were staying; and leisure intervals were partly spent at the Gramont mansion on the Champs Elysées. It was on a short stay in Deauville, that summer, that he first encountered what Cole Porter (moving currently in the same set) called the 'rich rich'. It seems likely, however, that John would have wanted to paint the Marchesa, and somehow have seized the opportunity, whether she had been rich or poor, an aristocrat of the Faubourg or a barmaid in the Tottenham Court Road. All the same, the two celebrated portraits he painted of this lady (the other belongs to the Hon. Mrs Mary Anna Marten) have tended to give the wrong impression: that John toadied to titled wealth. In fact, the artist could take only a little of this rarefied existence before stripping off his Sam Browne and seeking relief among the artists and writers of Montparnasse. It is altogether typical of the concealed philanthropist in John that, the Marchesa having lost every penny of two fortunes, he made a permanent contribution to her wants by banker's order. According to Sir Evan Charteris, the portrait was originally a full-length in pyjamas. Described by Lord Duveen as an 'outstanding masterpiece of our time', it passed to the Art Gallery of Ontario in 1934 for £,1500. 'The Marchesa Casati' had been painted in April 1919: after some lapse of time, John himself misdated it 1918.

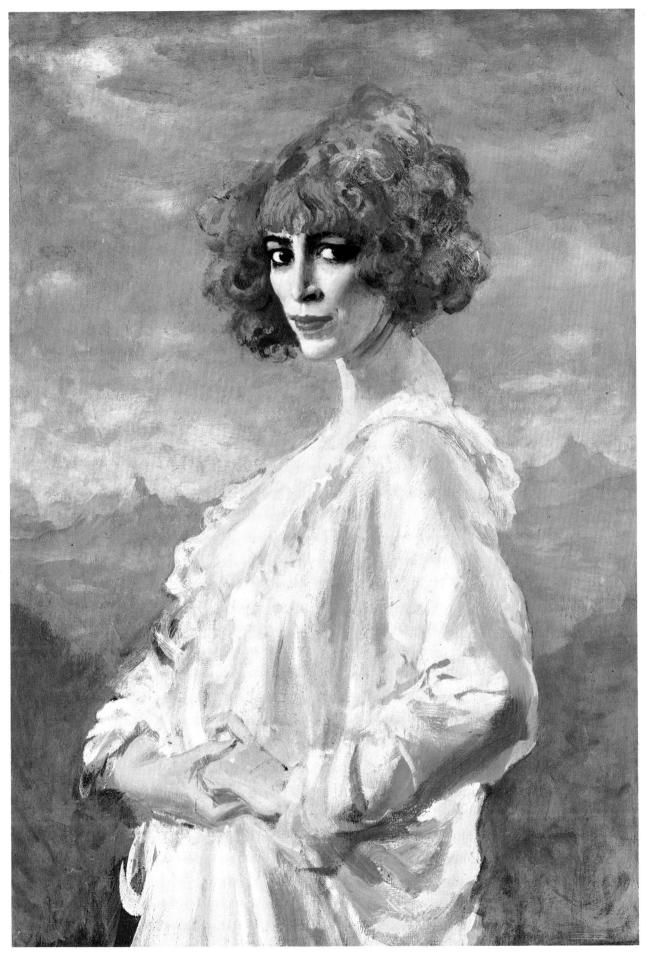

19 LADY OTTOLINE MORRELL, c. 1919

Oil on canvas, $26 \times 19 \ (66 \times 48.5)$

Exhibited R.A., 1954 (No. 354); Sheffield, 1956 (No. 26)

Collection: Lady Ottoline Morrell Mrs Julian Vinogradoff

This portrait shocked both those who knew the sitter and those who admired the artist. And Lady Ottoline, even more perceptive than Viscount D'Abernon (see No. 67a), well understood that what John regarded as a friendly likeness might seem to friends and relations, as well as to strangers, a malicious caricature. Press reaction, this time, finally succeeded in alarming John himself. 'I would like you to have that portrait,' he told Lady Ottoline, 'but I don't think it's one you would like to hand down to posterity as a complete representation of you.' Far from taking his advice, she hung it over the mantelpiece in her much frequented drawing-room at Garsington Manor. 'Whatever she may have lacked,' the artist observed, after her death, 'it wasn't courage.'

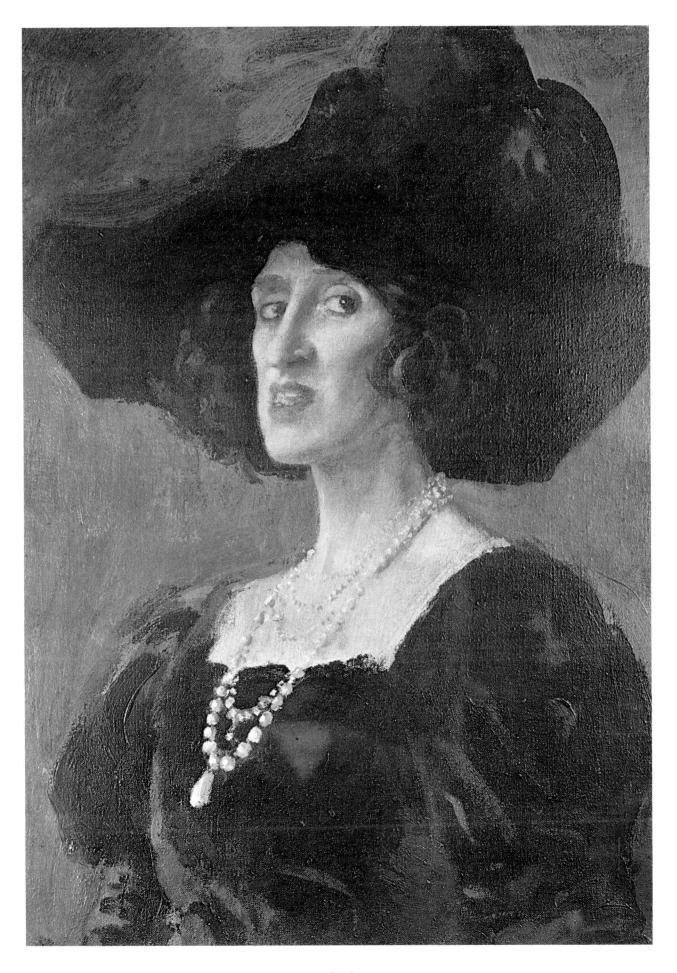

20 MADAME SUGGIA, 1923

Oil on canvas, $73\frac{1}{2} \times 65 \ (186 \times 165)$

Exhibited Alpine Club Gallery, 1923 (No. 12); International Exhibition, Carnegie Institute, Pittsburgh, 1924 (No. 224)

Collection: William P. Clyde, Jr *The Tate Gallery*

Guilhermina Suggia (1888–1950) studied at Leipzig and under Casals, whom she was believed to have married in 1906. Portuguese in origin, from 1914 she lived in England, giving her last concert at the Edinburgh Festival of 1949. John seems to have embarked upon the portrait with more than usual enthusiasm, and Mme Suggia to have been an unusually privileged sitter: 'John,' she related afterwards, 'does not only allow his sitters to view the unfinished portrait, but encourages criticisms.' Obviously, all went well to begin with, for Mme Suggia continues: 'On my first view of the picture, I was surprised to see how swiftly it had already progressed.' Soon, however, the artist ran into trouble, not so much over the position of the bow and the instrument itself as over the colour of the dress, which was more than once dramatically altered. Begun in 1920, the work dragged on beyond sending-in time for the R.A. summer show of 1922 and was only completed by 1923. Suggia played Bach throughout the sittings; by contrast, Miss Amaryllis Fleming, another distinguished cellist whom John painted with her instrument (though a young girl as yet and little known), remembers having the pose constantly 'frozen', and neither from her nor from any other sitters we have encountered were any criticisms invited! The grandeur of this portrait made a deep impression on the public, and Lord Duveen was felt to have performed an important service to the nation in buying it back from its American owner and presenting it to the Tate. For some years now, it has been on loan to the British Embassy in Athens.

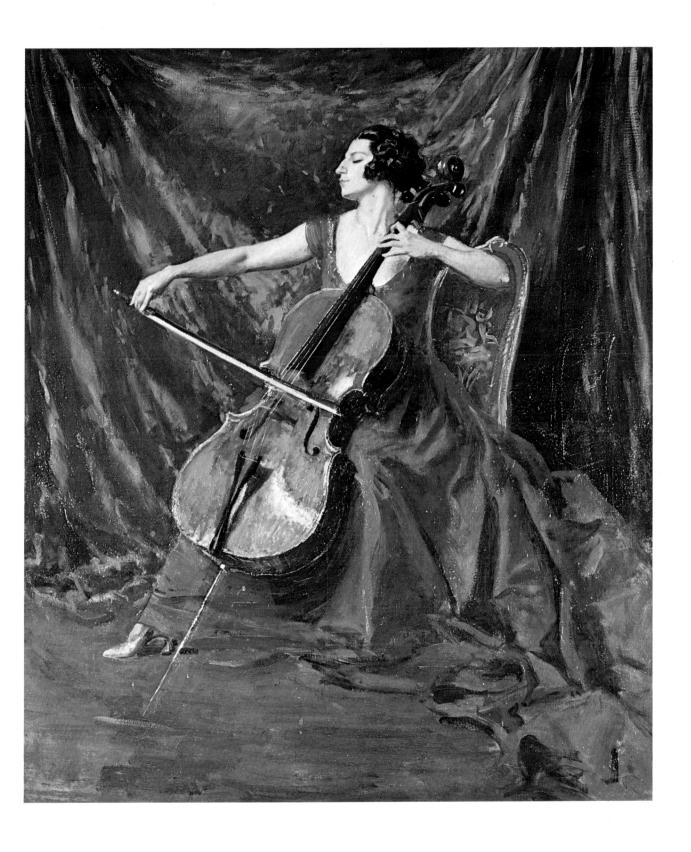

21 PEONIES IN A JUG, after 1925

Oil on canvas, 25×21 (63·5×53·5)

Signed 'John' top right

Exhibited R.A., 1954 (No. 421)

Mrs Thelma Cazalet-Keir

It was not till the mid-1920s that the artist began to devote some part of his energies to flower-painting. A number of examples appeared at an exhibition held at Messrs Tooth's in April—May 1929. Flowers were an alternative to, and in some respects (at least from Dorelia's point of view) preferable to, models. 'There's nothing much in the way of flowers here and I have no models,' John wrote to Dorelia from the Villa Ste Anne on 6th April 1928, 'I might as well be dead.' According to Dorelia, the very first flower picture — now owned by Admiral Sir Caspar John — was painted during the visit to Ischia in the early summer of 1925.

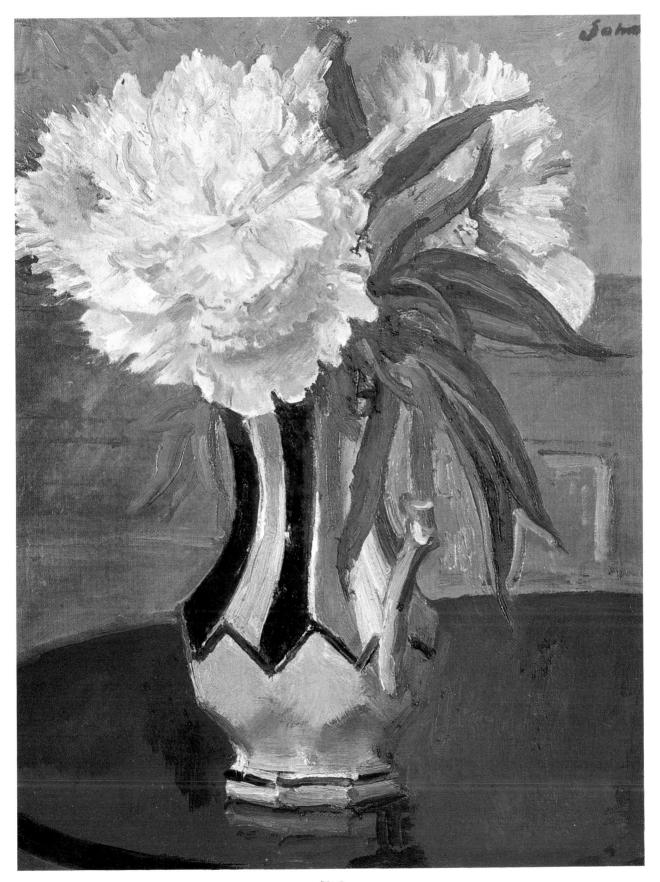

[87]

22 THE LATE LADY ADEANE, 1929

Oil on canvas, $74 \times 38 (188 \times 96.5)$

Exhibited R.A., summer 1951 (No. 132)

Sir Robert Adeane

Sir Robert Adeane's first wife was Miss Kit Dunn, daughter of Sir James Dunn and sister of the present Baronet. Fifteen sittings took place. John wanted more, but (as with the portrait of Joseph Hone and the majority of his more successful commissions during the last half of his life) it was smuggled away 'unfinished'. It appeared at the summer exhibition at Burlington House in 1951 and created a considerable stir: John had produced here, it was felt, the quintessential spirit of the Twenties.

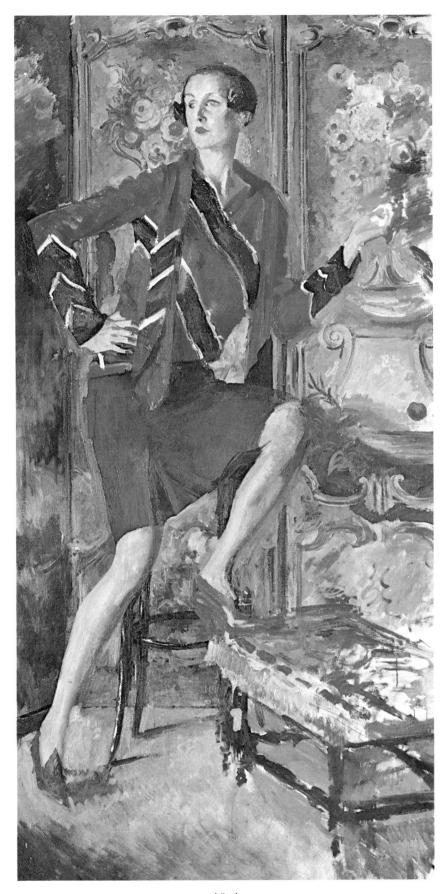

[89]

23 HEAD OF A JAMAICAN GIRL, probably 1937

Oil on canvas, $15\frac{1}{2} \times 12\frac{3}{4} (39.5 \times 35)$

Exhibited Temple Newsam, 1946 (No. 56); R.A., 1954 (No. 450); R.A., 1963 (No. 117)

Collection: Edward Le Bas

Mr Richard Burrows

This painting, some say, does not belong to the Jamaican series, but was painted in New York. The girl has even been described as 'East Indian'. Without doubt, portraits of coloured models constitute John's most successful *genre* during his later years and not all are Jamaicans. Here we keep the title accepted by the late Edward Le Bas, a distinguished painter himself and active in organizing the 1954 John retrospective. Thus we regard the picture as a likely product of 1937.

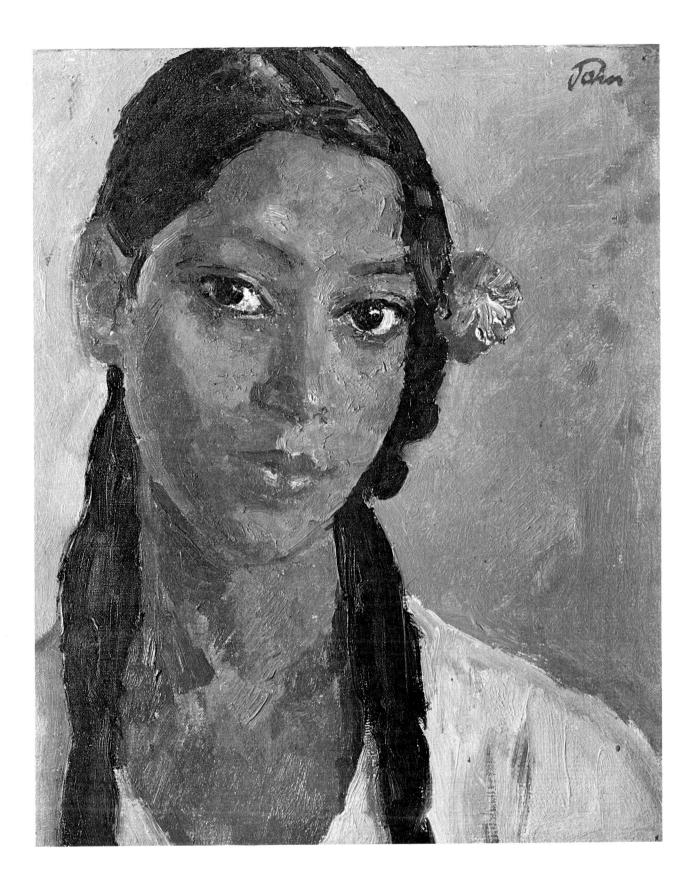

24 MIXED FLOWERS IN A GLASS JAR, c. 1938

Oil on canvas, 31×25 (78.5×63.5)

Signed 'John' bottom right

Exhibited Leicester Galleries, 1948 (No. 18)

Private Collection

The flower-painting reproduced here is unusually ambitious and seems to have brought the artist himself some satisfaction, since it hung in the drawing-room at Fryern Court for eight years. The signature was added later, at the present owner's request and through the good offices of John's daughter Poppet.

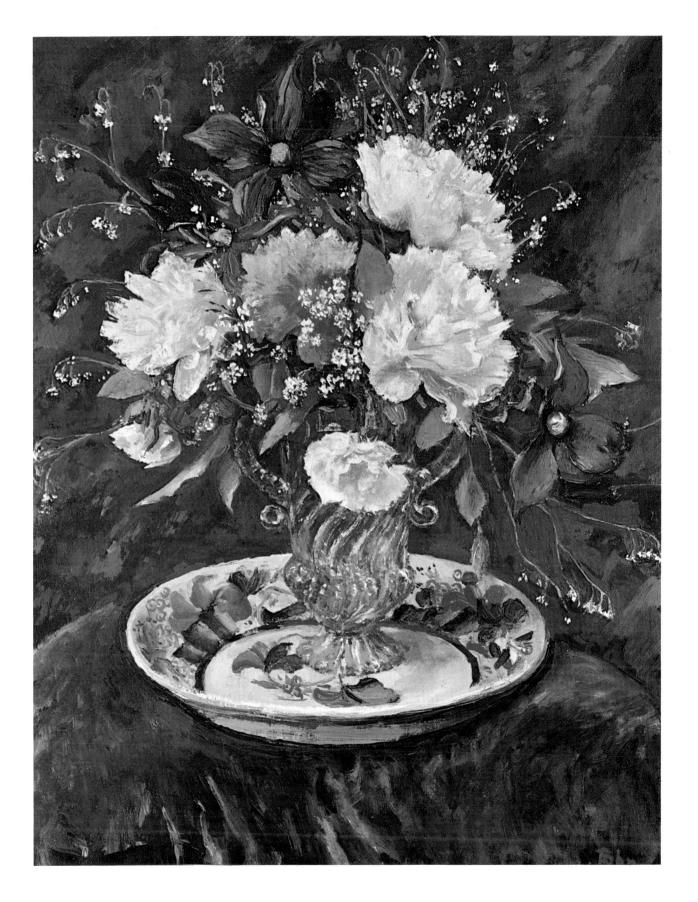

25 STUDIES OF A MALE NUDE WITH A STAFF, c. 1897

Charcoal on paper, $24 \times 18\frac{1}{4}$ (60.9 × 46.3), S

Signed 'John' bottom left Stamped on verso 'A. E. John Studio, July 1962' (this stamp appeared on all drawings in Messrs Christie's John Studio Sale of 20th July 1962)

Gwen Lady Melchett

As John's tribute to him in 'A Note on Drawing' long afterwards records, it was Fred Brown, the Slade Principal, as much as Tonks who inculcated this 'method of rendering the human form by a succession of rhythmical lines following the surface and explaining its structure'. No doubt, Brown himself had been brought up on the life-studies of Alfred Stevens (1817–1875), of the English school; but there existed throughout Europe many venerable precedents for the all-over linear mesh – going back at least as far as Dürer.

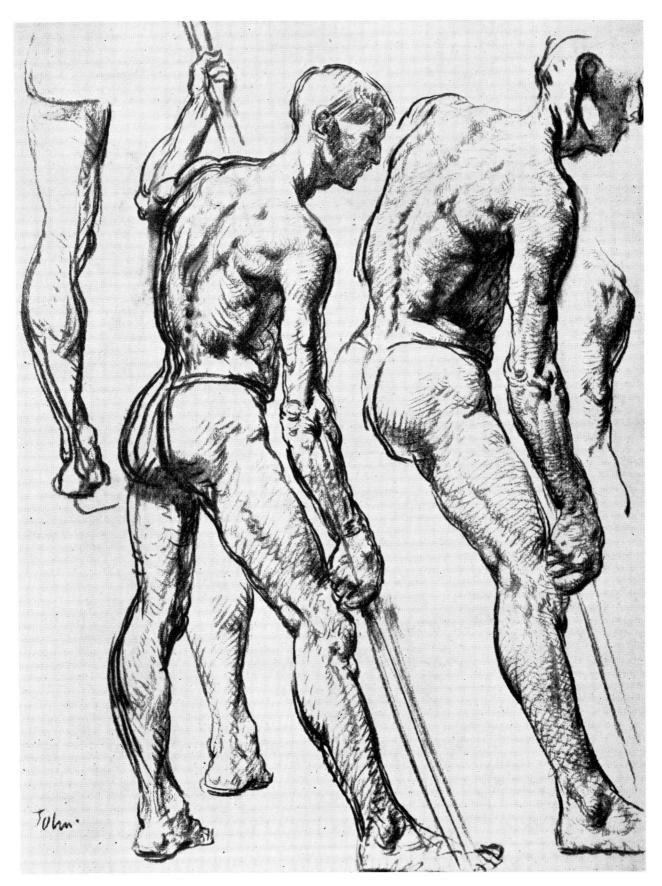

[95]

26 IDA NETTLESHIP, URSULA TYRWHITT AND GWEN JOHN, ϵ . 1897

Pencil on paper, $12 \times 9 (30.5 \times 22.8)$

Exhibited R.A., 1954 (No. 11)

Private Collection

Before Ida's ascendancy, and particularly in 1897, Ursula Tyrwhitt dominated John's affections. It was through his sister Gwen that he became close friends with a number of contemporary girl students at the Slade, where Ida had arrived as early as 1892. Gwen (1876–1939) herself registered in 1895, a year after her brother. Though neither Ida nor Ursula shared Gwen's remarkable genius, both continued to paint after leaving art school. The short pencil-strokes, often cross-hatched, show that the Brown–Tonks method could be abandoned at will. They resemble the scratches of an etching-needle. A large number of drawings of about this date are carried out in the same, anything but conventionally elegant, manner, and might be cited as evidence that John embarked upon the etching process rather earlier than the experts have supposed.

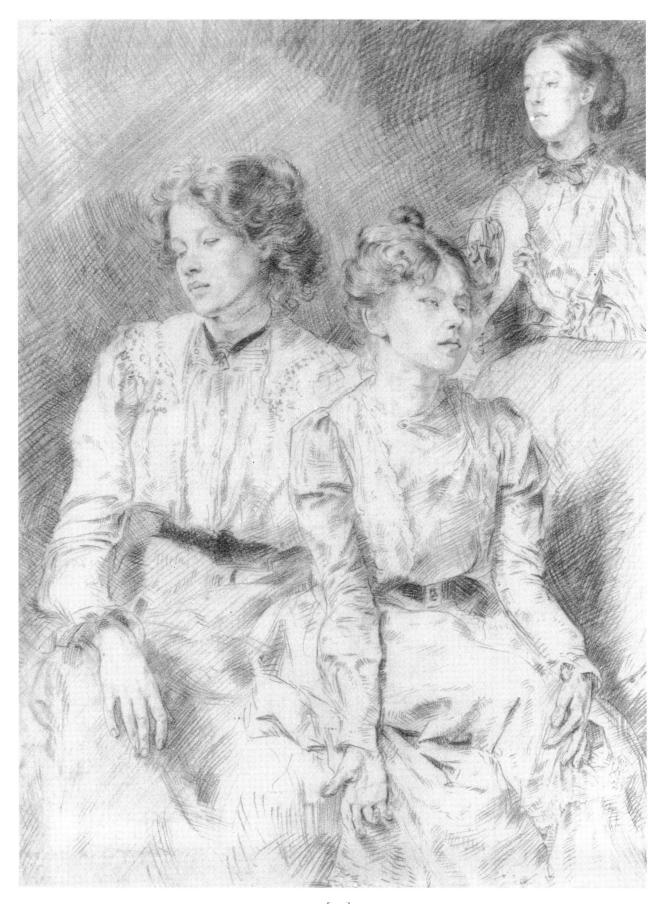

[97]

27 BENJAMIN EVANS, ? 1897–8

Etching, $5 \times 4 (12.7 \times 10.1)$

Signed 'A. E. John' bottom right on plate, and 'Augustus John' in pencil below

Listed in Campbell Dodgson as $14~\mathrm{I}/4$; now accepted as II/5 Messrs P. and D. Colnaghi

This is the rare, lightly etched state of the plate, which was heavily reworked in later states. The year scratched on the copper after the signature, while largely illegible, has '9' as third digit. We may suppose, therefore, a date of 1897 or 1898, since that would tally with the specific references to Evans and this plate in Chiaroscuro and account, at least partly, for the etching's strongly Rembrandtesque character. 'Benjamin Evans, a Welshman whom I had met at school at Clifton, made a third party in the trio we formed [of fellow-students, including McEvoy, at the Slade], John writes. 'Evans was an original and witty draughtsman, well versed in Rembrandt. At his suggestion I attempted etching: my first plate was a portrait of him.' The trio embarked on a donkey-cart expedition through Pembrokeshire in 1897; and perhaps Evans' Romany-style hat indicates a shared enthusiasm for the open road and the wind on the heath. In the year following, the trio visited Amsterdam, again at the suggestion of Evans, to see a Rembrandt exhibition held at the Stedelijk Museum between 8th September and 31st October. The sitter finally gave up art to become a sanitary engineer (Chiaroscuro, pp. 43–6). We ought to add that Dodgson, who ascribed the earliest etchings to 1901, would have regarded a date in the 1890s for this plate as an error on the part of the artist. This opinion is respected in our own queried dating here.

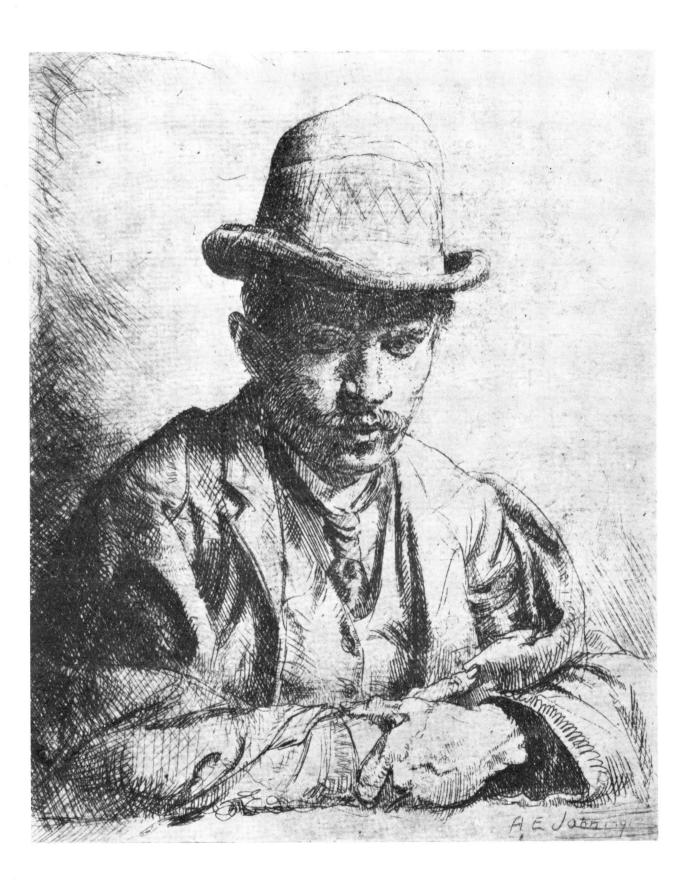

28 MOSES AND THE BRAZEN SERPENT, 1898

Oil on canvas, $60 \times 84 (152.5 \times 101.5)$

Exhibited Birmingham, 1952 (No. 34); R.A., 1971 (No. 11)

The Slade School of Fine Art, University College, London

'And Moses made a serpent of brass, and put it upon a pole; and it came to pass, that if a serpent had bitten any man, when he beheld the serpent of brass, he lived' (*Numbers*, XXI, 9). Such was the solemn and rather intimidating subject set for the Summer Composition at the Slade which won for John the First Prize in 1898. While not much to the modern taste, this represents a concentrated study of the Old Masters wholly laudable in a beginner, and a most courageous attempt to work out his ideas on the grand scale. Rembrandt and El Greco form an uneasy partnership in what the artist described – with proper zest – as his 'Holy Moses treat' (letter to Michel Salaman, of June 1898). The influence of other great forebears is also evident, though in places it is difficult to distinguish between Mannerism and mannerisms.

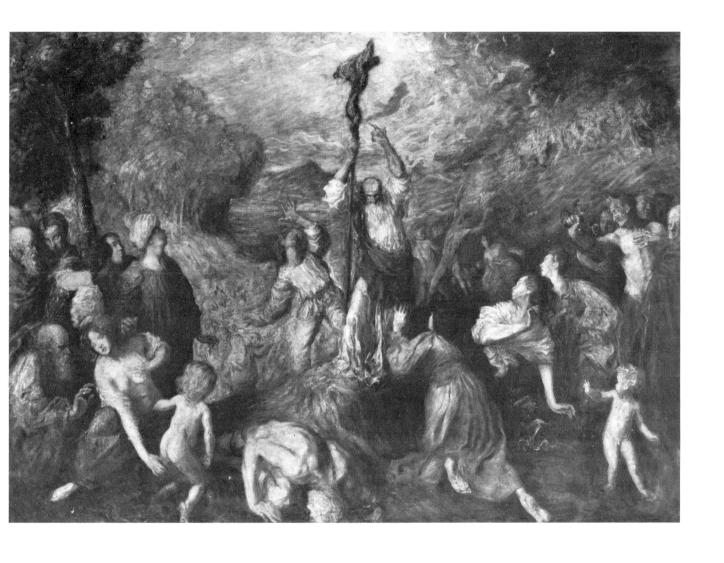

29 TETE FAROUCHE (PORTRAIT OF THE ARTIST), ? 1899–1900

Etching, $8\frac{1}{4} \times 6\frac{5}{8} (21.3 \times 14.3)$

Listed in Campbell Dodgson as 10, second state

The National Museum of Wales

One of the most remarkable features of John's output is the very large proportion of self-portraits. This holds good for the etchings, too, where a long series of mirrored heads and busts seems deliberately to invite comparison with Rembrandt. If the title 'Tête farouche' means, as it should, 'Head of a Rebel', then it could hardly have been better chosen for the years immediately succeeding 1898, when John left the Slade. Both Michel Salaman and John Everett testify to the change in their friend's character. Removed from Tonks' daily supervision, John was at his wildest, his most 'farouche', precisely during 1899–1900, when, among other escapades, he led the police a dance across the flower-beds of Hyde Park and himself danced on the roof of St John's Church, Charlotte Street. Dodgson would, one presumes, have assigned this print, though undated, to 1901. The impression reproduced has been clean-wiped; others carry a great deal of plate-tone, with enhanced dramatic effect.

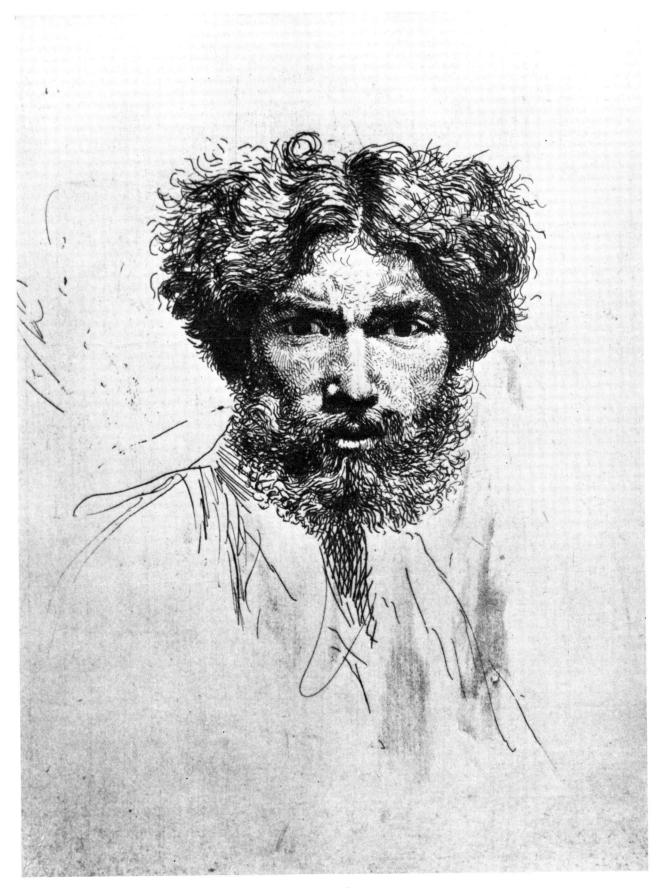

[103]

31 JOHN SAMPSON, ? 1903

Chalk on paper

Signed and dated 'John f. 03 [?]' bottom right

Exhibited N.E.A.C., winter 1903 (No. 132)

Present owner untraced

John Sampson (1862–1931), Liverpool University College Librarian when John arrived there in 1901, introduced the artist to Gypsy modes and manners. John proving an apt pupil in the study of Romani, they visited encampments together and shared longer journeys into Wales by horseand-van. Later, John sent back notes of Gypsy dialect made during his wanderings in Provence. Sampson was a strange mixture of sound scholar and sentimental Romantic. His Romani poems (translated by himself) suggest that any influence he exerted over John was an unfortunate one. In his 'The Apotheosis of Augustus John', God appoints the artist Grand Vizier of Heaven, 'for I must really have a little amusement', a choice of court comic which would certainly have turned out disastrously. Altogether, Sampson encouraged the stage Gypsy in John, and helped to promote an image of larger-than-life, amorous, wine-bibbing jollity little to the taste of post-Georgian connoisseurs. For the best side of Sampson, we need to consult *The Dialect of the Gypsies of Wales*, first published in 1926, a work of fascinating erudition. We have assumed that this, the only known (though unlocated) drawing of Sampson, must be that recorded as exhibited at the N.E.A.C. in 1903. A reproduction of it can be found, facing p. 58, in Chiaroscuro.

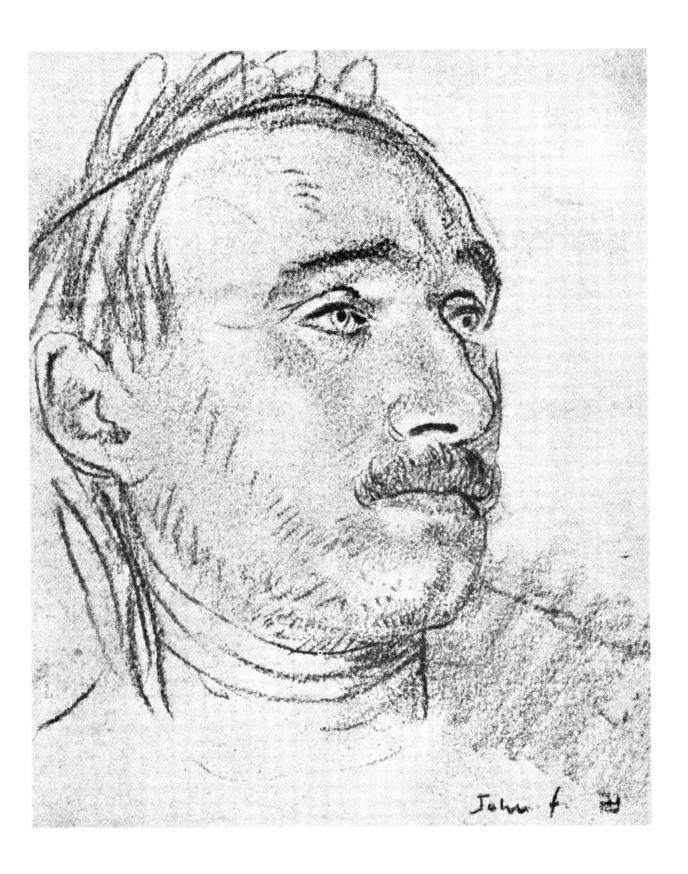

[107]

32 WYNDHAM LEWIS, c. 1903

Etching and drypoint, $6\frac{15}{16} \times 5\frac{1}{2} (17.7 \times 13.9)$

Listed in Campbell Dodgson as 19, fourth state Signed 'John' and dated (erroneously) '1893' bottom right on plate

Messrs Thos Agnew and Sons

It was William Rothenstein who introduced Wyndham Lewis (1882–1957) to his older friend Augustus, probably in the summer of 1902. Lewis, shy and ambitious, at first revelled in John's careless brilliance. On his side, John envied Lewis' literary gifts. Mutual admiration, however, could give place to frequent disagreements, which continued throughout their lives. In 1938, John resigned from the Royal Academy, ostensibly on account of its rejection of Lewis' portrait of T. S. Eliot – then later, when he saw the picture, announced that his sympathies were after all with the hanging-committee. John did another etching of the same sitter (C.D., 18). By common consent, that reproduced is the more sharply observed of the two and, indeed, one of his very finest plates. Though John may have made mistakes in dating, as here, on a particular plate, it is difficult to understand his attributing plates to the 1890s if he never touched a needle till 1901. One's first introduction to the novel paraphernalia of etching is not so easily forgotten.

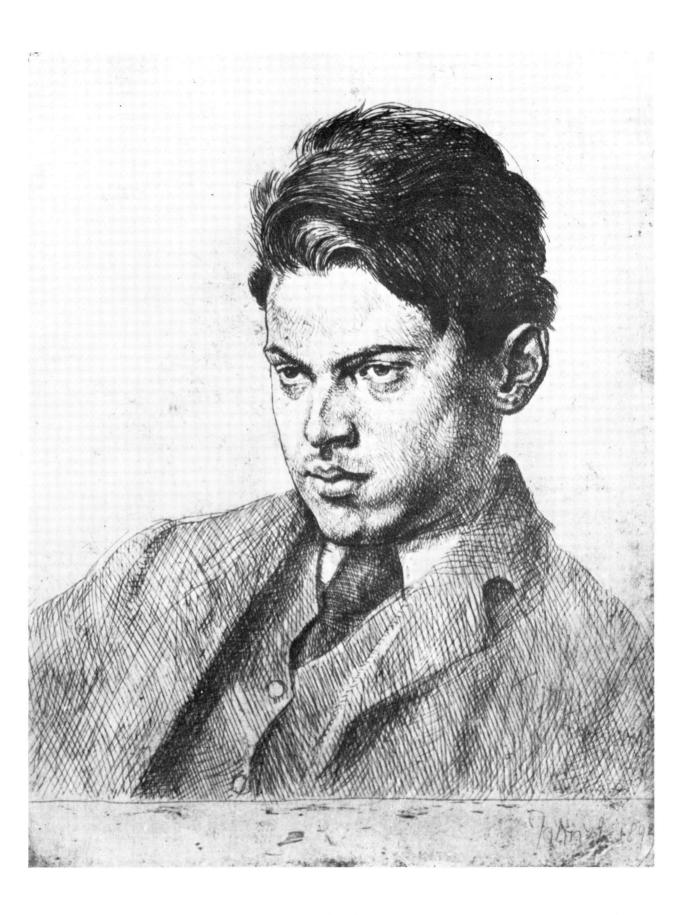

[109]

33 STUDIES OF YOUNG CHILDREN, c. 1904

Pencil on paper, $9\frac{1}{2} \times 13$ (24·1×33)

Private Collection

The children are David and Caspar, aged about three and two respectively. The 'location' could be the house at Matching Green, Essex, with large garden, orchard and stables, which Augustus and Ida took on a two-year lease in November 1903. The drawing is interesting in showing that from the beginning the boys' home-designed clothes were more picturesque than convention approved. One can also take it as a very early manifestation of the use made of David and Caspar (then Robin, Edwin, Pyramus and Romilly) as – after their mothers – John's favourite models. Though charcoal had been the main vehicle of drawing at the Slade, John seems to have been most at home with a lead pencil during the years immediately following.

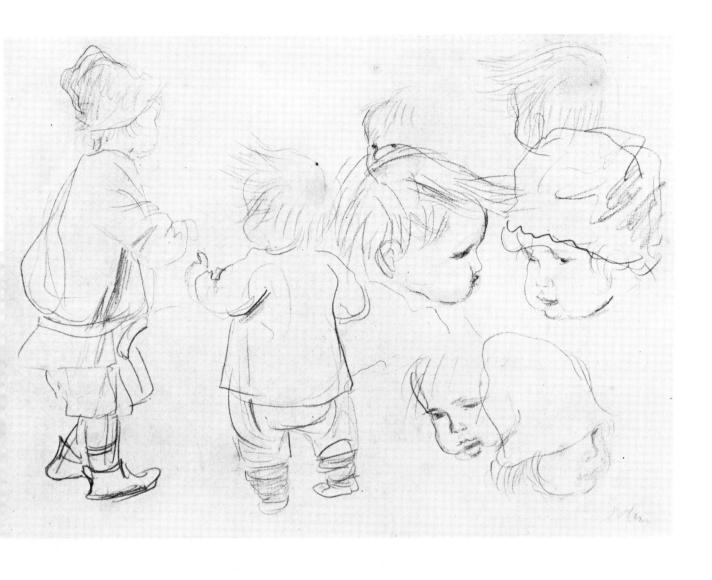

34 CARAVAN AT DUSK, 1905

Oil on canvas, $32 \times 35\frac{3}{4}$ (81·5×91)

Exhibited Temple Newsam, 1946 (No. 12)

Collection: The John Estate; with the Piccadilly Gallery and the Tib Lane Gallery, Manchester Mr Richard Driver

One of the most striking of the early landscapes, it includes the caravan acquired from Salaman on the 'never-never' and a Gypsy tent of traditional hazel-rod construction. It was on this stretch of moorland (still bleak enough) in the straggling parish of Lydford, that Dorelia's son Pyramus was born as early summer approached. 'It is adorable and terrible here,' wrote Ida, who came down with her sons to assist: and we can feel John's appreciation of these qualities. When not painting, he read or played with a toy boat in the stream where Ida washed the family linen, seen here drying on the grass. The Dartmoor experience, after a short interval, inspired the artist to take even more ambitiously to the road. A new celebration of the beauties of the English countryside was initiated among painters, by Innes, Derwent Lees and John himself; among writers, by W. H. Davies and Ralph Hodgson. The picture's fine colour has been re-established after a recent cleaning.

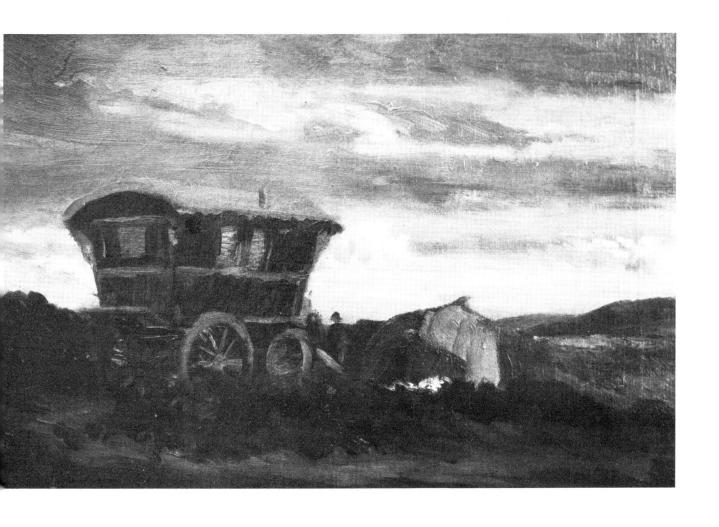

35 THE WOMAN IN THE TENT, 1905

Oil on canvas, $14\frac{1}{2} \times 17\frac{3}{4} (37 \times 45)$, S

Signed 'John' top centre

Collection: Arthur Crossland; with Adams Brothers

Mr Peter Harris

John wrote to the Hon. Evan Morgan on one occasion (no year given): 'You know very well I think your "Woman in the Tent" is the best example of my work at that period.' There are, of course, several paintings by John of women (that is, Ida and Dorelia) in tents, and the Morgan picture entitled 'The Woman in the Tent', shown at the R.A. in 1954, measured $21\frac{1}{4}\times17$, a very different format. All the same, Mr Harris' version is exquisite enough to deserve its author's highest praise. An 'In the Tent', without dimensions given and therefore unidentifiable, can be found in the catalogue for the N.E.A.C.'s 1906 winter exhibition.

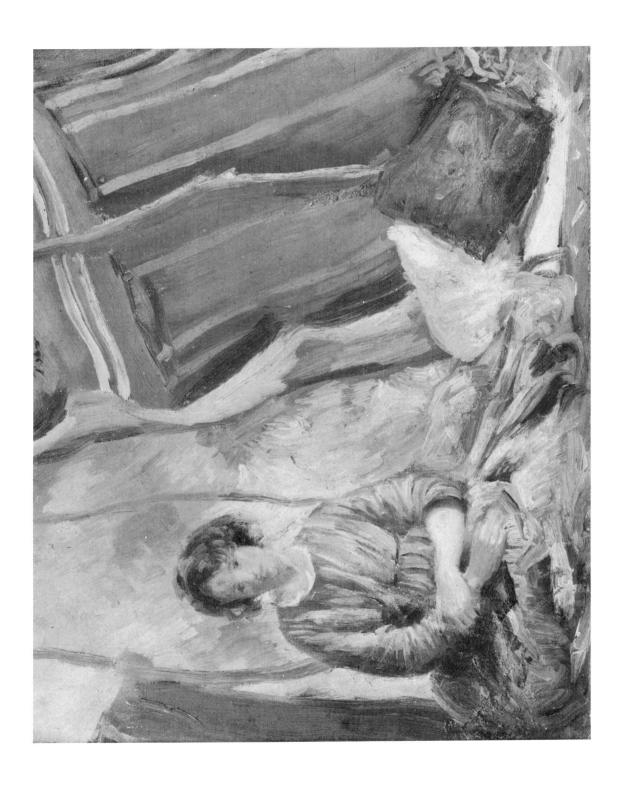

37 ALICK SCHEPELER, 1906

Pencil on paper, $8\frac{1}{2} \times 8\frac{1}{2} (21.6 \times 21.6)$

Signed and dated 'John 1906' within the hair-strands, lower right

 $\begin{array}{l} Exhibited \, N.G., 1940 \, (No. \, 92) \, ; \, R.A., 1954 \, (No. \, 76) \, ; \\ Sheffield, 1956 \, (No. \, 70) \end{array}$

Collection: Dr Louis Clarke
The Fitzwilliam Museum, Cambridge

John was most himself when under the influence of a new passion; that is, most surely himself as an artist. In 1906 he met Alick Schepeler, a secretary employed by *The Illustrated London News*, and the drawings he made of her form a unique yet highly characteristic section of his *oeuvre*. Always concerned to wrap in mystery the women he loved, John claimed a 'Slavonic origin' for Alick (baptised Alexandra), who was in truth of mixed Irish and German parentage, though born near Minsk in 1882. Some of the drawings are given the title of the water-sprite, Undine. There were paintings, too: 'La Séraphita', reputedly the finest, having suffered destruction in one of the artist's cigarette-fires in the 1930s. Technically, the Alick Schepeler drawings display, more than any other group (including the studies of Euphemia Lamb), the use of oblique-stroke shading. It is this stroke, moving downward from right to left, that reminds one of Leonardo silverpoints, despite the directional difference caused by Leonardo's left-handedness. The Slade life-school method seems to have remained an exclusively anatomical exercise.

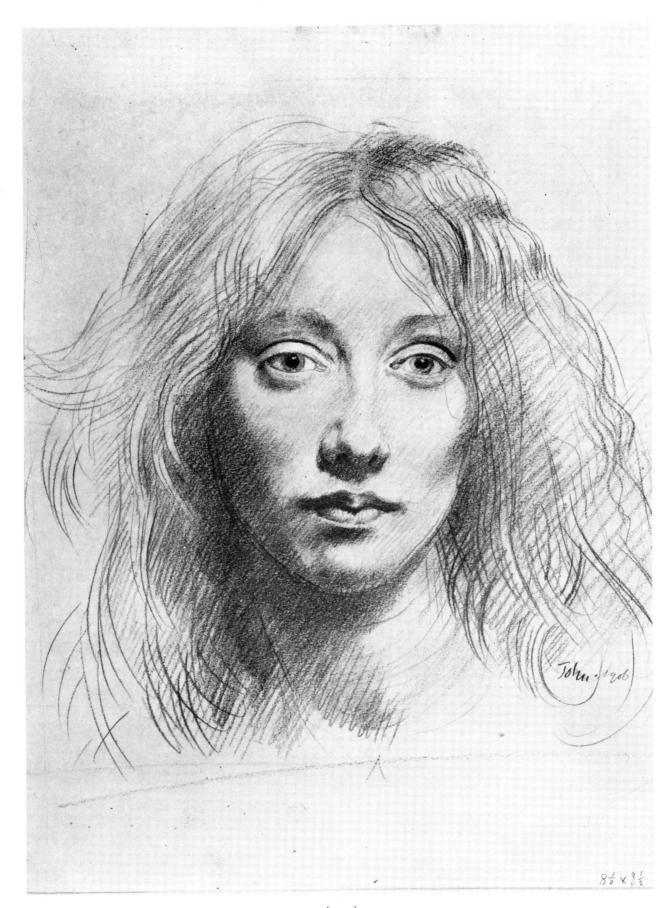

[119]

39 PYRAMUS ASLEEP, c. 1906

Pen and brown ink on paper, $4 \times 10^{\frac{3}{4}}$ (10.2×27.3)

Signed 'John' lower right

Exhibited N.G., 1940 (No. 4); R.A., 1954 (No. 43)

The John Estate

For biographical details, see note to Pl. 12. Perhaps twelve months after this drawing was made, John wrote to Will Rothenstein from Equihen: 'Pyramus grows more lyrically beautiful every day. He is like a little divine phrase from Shelley or Wordsworth.' The medium is an unusual one for John. There are plenty of reed-pen and fountain-pen drawings from his hand, but we know of no other important work produced with a steel nib and what looks like 'Prout's Brown'.

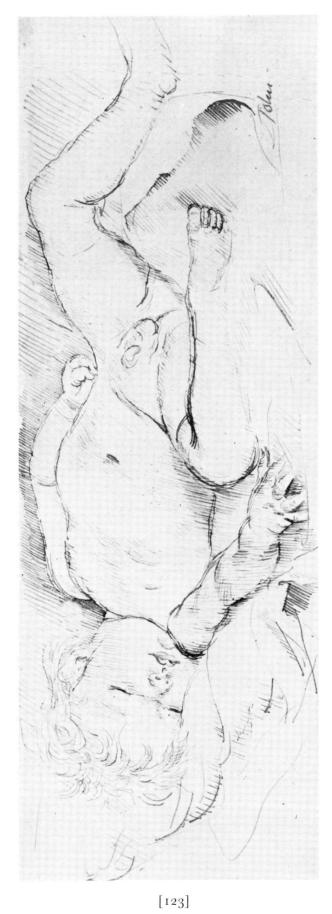

40 ALICK SCHEPELER, 1906–7

Pencil on paper, $12\frac{1}{4} \times 9\frac{1}{8} (31 \cdot 1 \times 23 \cdot 2)$

Signed 'John' lower-middle right

Exhibited in the Wiggin Gallery, Boston Public Library, 1951

Collection: with the Childs Gallery, Boston
The Print Department, the Public Library, Boston, Massachusetts

The hat would be important. The one subject above all others upon which John and Alick tirelessly exchanged views was that of clothes. When they were separated, she had to describe for him in detail her dress of the day. 'Tell me, Undine,' he inquired, on one occasion, 'how are your shoes wearing? It seems so *fitting* that you – a soulless, naked, immortal creature, come straight out of the water – should take to *shoes* with such a passion!'

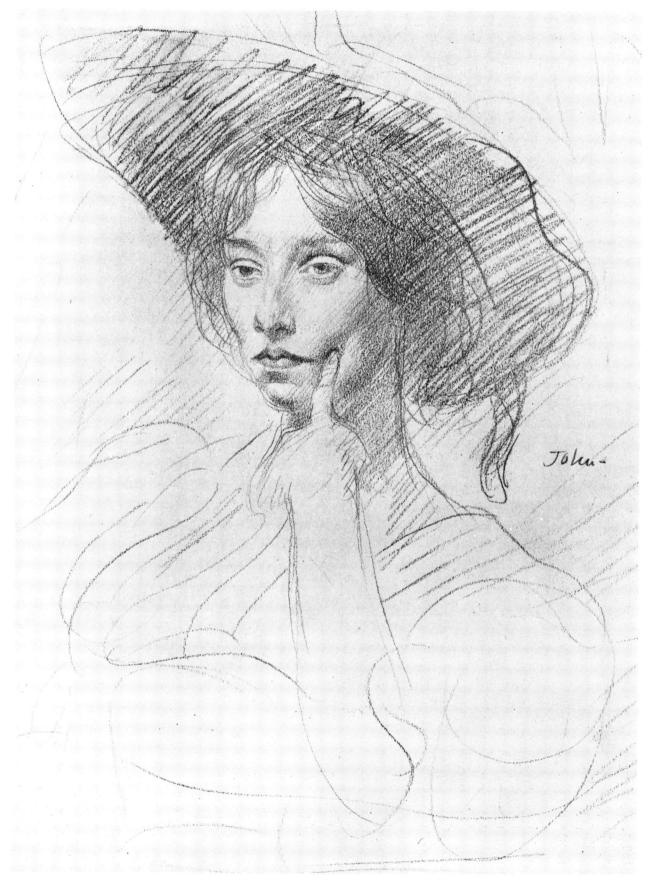

[125]

42 PEASANT WOMAN WITH BABY AND SMALL BOY, ϵ . 1907

Charcoal and tempera on paper laid upon canvas, $71\frac{1}{4} \times 32$ (181 \times 81·5)

Collection: The John Estate Present owner untraced

About 1907, John began to find the atmosphere of the New English Art Club 'asphixiating'. Forced to exhibit there, he confessed: 'I always want to slough my skin after the bi-annual celebrations [the regular summer and winter show] and go into the wilderness to bewail my virginity.' Bewailing his virginity commonly took the form of painting large unsaleable canvases in which with a mischievous delight he abandoned every scrap of elegance, summoning up in its place 'elements drived from remote antiquity or the art forms of primitive peoples'. It is hardly surprising that the Picassos of the Blue and Rose Periods leave a mark on his paintings at this time. He recognized in Picasso, when the two artists met that summer, not only a co-disciple of Puvis de Chavannes but a fellow-sympathizer with the outcasts of society. Like Picasso's, John's noble vagrants are set symbolically on the barren shore of an inhospitable sea.

Something needs to be said about the medium here employed. The Birmingham artist, Joseph Southall (1861–1944), inspired by Eastlake and Cennino Cennini's treatise on painting, taught tempera to A. J. Gaskin and C. M. Gere. In 1901 the Society of Painters in Tempera was founded (for modern purposes, 'tempera' means pigment mixed with yolk of egg). John would seem to have little in common with the precise, almost Pre-Raphaelite Birmingham school; but no doubt the enhanced brilliance and purity of colour had attracted him to the method, and the Society later expanded its title to include Mural Decorators, a field in which John found himself increasingly interested. It was one of several societies of which he later became president.

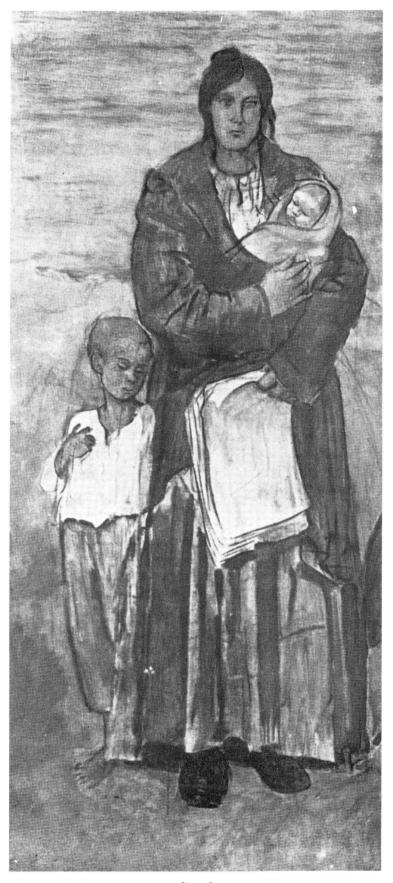

[129]

43 DORELIA STANDING, c. 1907–8

Pencil and watercolour on paper, $18 \times 10^{1\over 2} \ (45.7 \times 26.7)$

Signed 'John' bottom left

Exhibited British Council, Empire Exhibition, 1936 (No. 503); Arts Council, 1948–9 (No. 77); University of Hull, 1970 (No. 45)

Collection: Lord Henry Cavendish-Bentinck *The Tate Gallery*

Though in Ronald Firbank's *Caprice*, Mrs Sixsmith 'placed a hand to her hip in the style of an early John', and one often sees in one's mind's eye a whole string of John models thus posed, the variety of stances adopted for Dorelia is most remarkable. In fact, in none of the three examples chosen here, does she rest a hand on her hip. More characteristic than any particular placing of the hands (and this may not have been lost upon Mrs Sixsmith) is John's insistence that the weight of the standing figure be carried on one leg. While this is a traditional, and particularly Renaissance, pose going back to the Antique, its significance for John must have been connected with the emphasis given to the outthrust iliac crest with its pad of fat and muscle, so much more prominent in a woman, here further emphasized by the pleats springing away from the tight bodice of the dress.

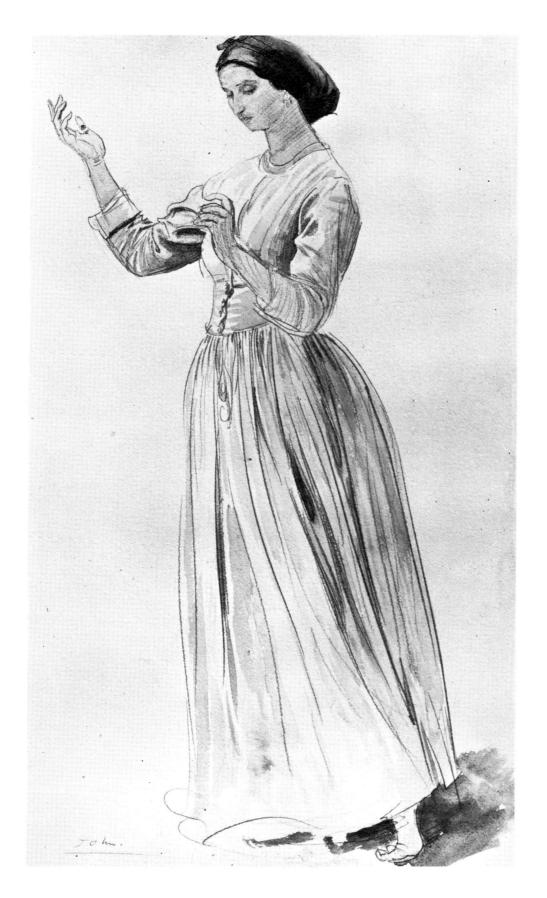

[131]

44 STUDIES OF DORELIA, c. 1907–8

Pencil on paper, $15\frac{3}{4} \times 9$ (40 × 23)

Signed 'John' low right, with further inscription: 'Augustus John to Frank Harris Nov 24 1909'

Exhibited R.A., 1954 (No. 143); R.A., 1968 (No. 639)

Mrs Thelma Cazalet-Keir

Besides their intrinsic interest, these two studies arouse further attention on account of the inscription. Most people succumbed momentarily to the boisterous charm of Frank Harris (1856–1931), but in John's recollection it was he himself – though unwillingly – who fascinated Harris. The history of their relationship remains vague. We should like to know more about the luncheon-party at which Lord Grimthorpe, Harris and John were joined by Harris' protégé, the brilliant, tragical Richard Middleton. But if John could still tolerate Harris in 1909, mutual attraction had ceased to operate after 1910, when the artist was persuaded to put up for a night or two with Frank and Nelly at their villa in Nice. John, made uneasy by Mrs Harris' peculiar behaviour, fled at dawn. Even this conjunction of Casanovas could not survive so flagrant a breach of etiquette.

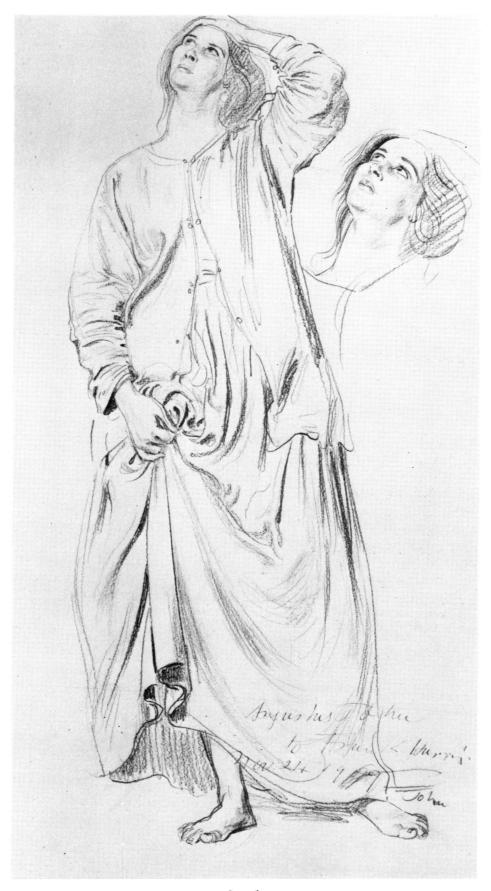

[133]

47 LADY OTTOLINE MORRELL, c. 1908

Pencil and gouache on paper, $11\frac{7}{8} \times 8\frac{3}{8} (30 \cdot 1 \times 23 \cdot 8)$

Signed 'John' bottom right

Exhibited Reid and Lefevre, 1949 (No. 55); Portraits, Inc., New York, 1966 (No. 71); Pierpont Morgan Library, New York, 1971 (No. 47)

Mr and Mrs Benjamin Sonnenberg

A very large number of John's pen-and-wash and watercolour drawings of Lady Ottoline have come to light. Most of them were carried out during the first months of their knowing each other. The model walked over daily from Bedford Square to Fitzroy Street and inspired John to produce endless sketches of the 'delicatest and noblest woman' he had known. Though Ottoline might be thought to be of help to him professionally, he was more concerned with petitioning her on behalf of his friends, in particular Epstein and Henry Lamb. The latter, indeed, in some degree replaced him. But the warm friendship continued till Lady Ottoline's death in 1938. Lady Ottoline Morrell, who was married to Philip Morrell, M.P., conducted one of the most celebrated salons of the day at Garsington Manor, near Oxford – but in that area of her activities John played little part.

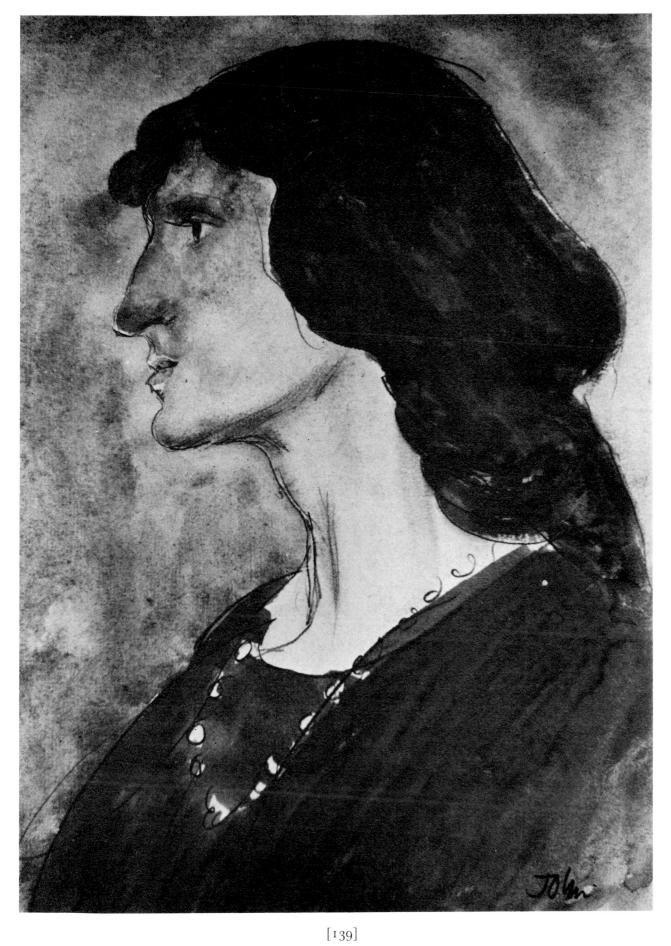

51 EDWIN AND ROMILLY, c. 1910

Oil on panel, $13 \times 9\frac{1}{4}$ $(33 \times 23 \cdot 5)$

Exhibited R.A., 1954; University of Hull, 1970 (No. 27)

Private Collection

A taste (in the artist's own words) for the 'fresh and raw' often took hold of the immensely sophisticated draughtsman. Long before Roger Fry introduced them to the great British public through the celebrated exhibitions of 1910 and 1912, Gauguin and Van Gogh had powerfully impressed John, who looked on life for a while, as Sir William Rothenstein recalled, with an '"early" eye'. This little work seems to emulate the naïve and photographic qualities of the Douanier Rousseau, Edwin and Romilly posing as if for a snapshot against a background of Martigues olive-trees. The two boys, one Ida's son, the other Dorelia's, were much in each other's company. They followed David, Caspar and Robin to lessons at Dane Court, Parkstone, on the same day. Later, they attended boarding-school in France together.

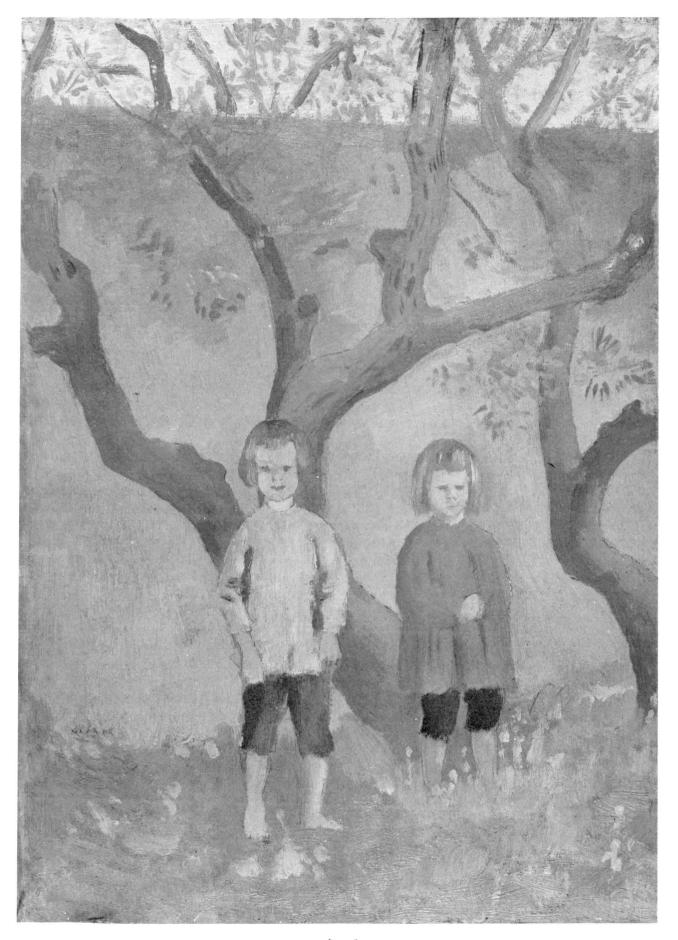

[147]

57 CARTOON FOR GALWAY (detail: left and central panels), 1916

Oil on canvas, $114\frac{1}{2} \times 472\frac{1}{2}$ (291 × 1200)

Exhibited R.A., 1916 (No. 541)

The Tate Gallery

Unfinished 'Galway' is: the suitably grand term *cartoon* insists upon this. Yet one hesitates to describe it as incomplete. 'I'm thinking out a vast picture synthesizing all that's fine and characteristic in Galway City – a grand marshalling of the elements,' John wrote to Dorelia from Galway on 5th October 1915. 'It will have to be enormous to contain troops of women and children, groups of fishermen, docks, wharves, the Church, mills, constables, donkeys, widows, men from Aran, hookers [two-masted fishing-boats of Dutch origin], etc, perhaps with a night sky and all illuminated in the light of a dream. This will be worth while – worth the delay and the misery that went before.' But when he went out into the streets with his sketchbook he was at once identified as a German spy - 'so that is another drawback, and a big one,' he told Dorelia. In a letter to Ottoline Morrell, he complained: 'These are wonderful people and it is beautiful about the harbour but if one starts sketching one is at once shot by a policeman . . . It would be worth while passing 6 months here given the right conditions.' The conditions being so bad, he decided to paint from memory. 'Painting from nature and from imagination spells defeat I see clearly,' he wrote to Dorelia. Much of the actual painting was done in his studio at Alderney. His stay in Galway covered two autumn months of 1915 (he had also been in Ireland in June). 'Galway' was shown at the Arts and Crafts Exhibition at Burlington House in 1916, as noted above. John is said to have covered a hundred square feet in a single week, working feverishly before his impressions clouded over: a miracle since disputed. It may be noted that he was not a member of the Arts and Crafts Society, which had nevertheless commissioned him to produce the vast cartoon. To see it, the visitor ascended the Academy staircase, reached a landing representing Trafalgar Square turned into a national Campo Santo; passed through an 'Ecclesiastic' Section; then finally entered the area entitled 'University', where 'Galway' somewhat inappropriately shared the walls with William Rothenstein's 'Memorial for Members of the English Universities Who have Served in the War'.

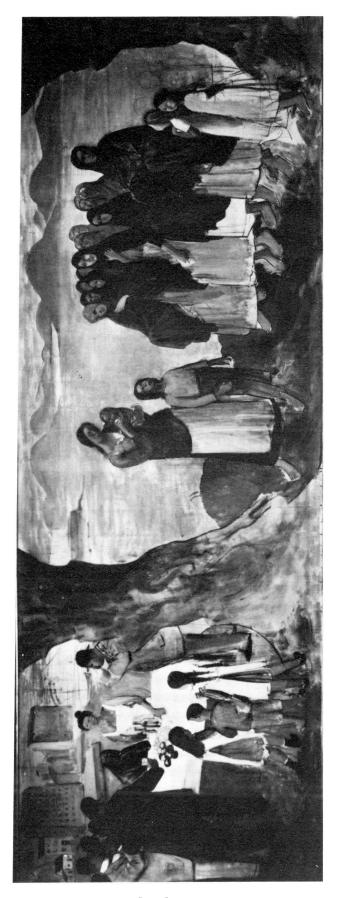

[159]

58 ARTHUR SYMONS, 1917

Oil on canvas, 34×25 (86.5×63.5)

Exhibited Scott and Fowles, New York, 1949; Albright Art Gallery, Buffalo, 1949: no catalogue numbers.

Collection: John Quinn; Mrs Millicent A. Rogers Mr Peter A. Salm

Arthur Symons (1865–1945), poet, essayist and critic, had been a leading contributor to *The Yellow Book* and editor of *The Savoy*, a magazine made unforgettable by Beardsley's drawings. Timidly in pursuit of riotous living himself, Symons found a hero of the new century in John. He pursued the artist with fulsome dedications from the year of their meeting, 1902. In return, John breathed some real life into an existence arid with introspection and trembling always on and over the verge of insanity. The strange relationship, encouraged for some years by John Quinn, who was interested in both, continued till Symons' madness drove him into necessary seclusion. This portrait was one of Quinn's last and most grudging John purchases, and at £400 he considered it 'about £200 too much'. It is now looked on as one of the artist's subtlest interpretations of contemporary men of letters.

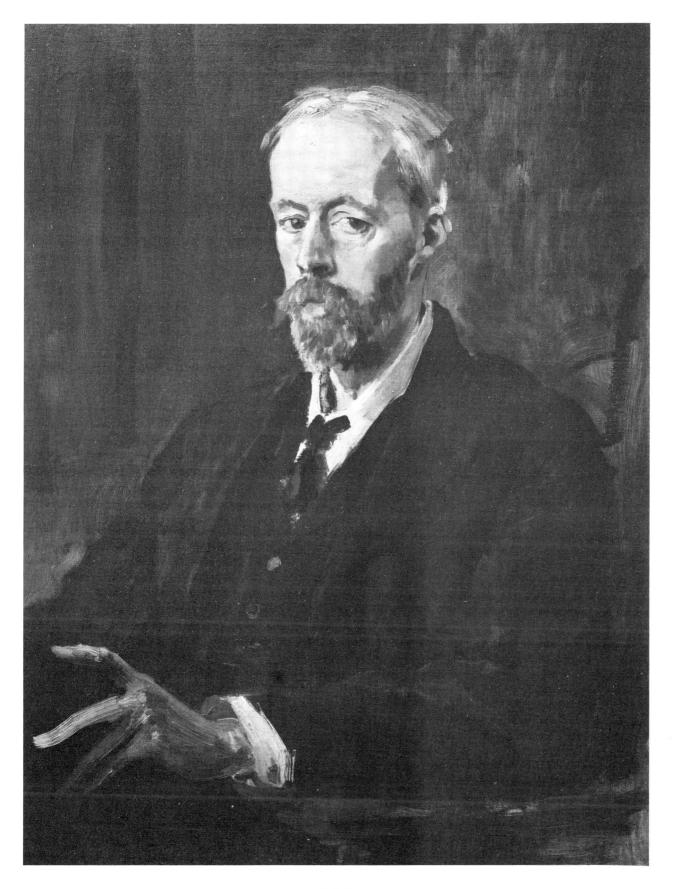

[161]

59 FRATERNITY, 1918

Oil on canvas, $93\frac{1}{2} \times 57 \ (237.5 \times 145)$

Exhibited at the Tate Gallery, 1922–1924

The Imperial War Museum

John's early patron Quinn, busy making money on the safer shores of the Atlantic, was alarmed lest the war should give a 'tremendous push to sentimentality in art'. No doubt, his fears were often substantiated. Though protected by an egocentricity almost as formidable in these circumstances as the concrete honeycombing of Wytschaete Ridge, John himself produced a tear-jerker or two (cf. the embarrassing lithograph, 'Britain's Ideals in the War: the Dawn'), but 'Fraternity' is not one of them. It says its piece – and the brotherhood of arms is a risky subject – with great dignity and restraint, and does not suffer in the least when compared with the classic Nashes and Nevinsons.

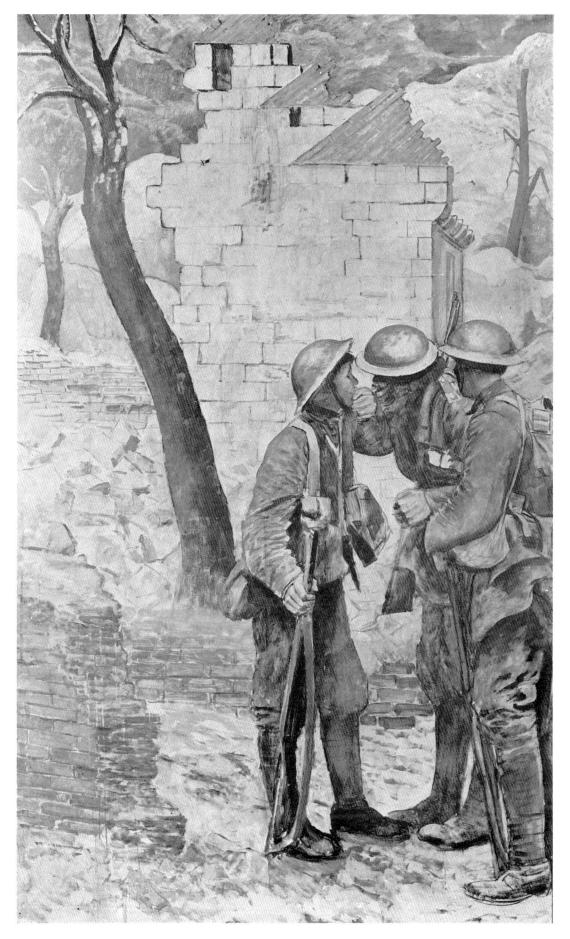

[163]

60 CANADIANS AT LIEVIN CASTLE, 1918

Oil on canvas, $14\frac{1}{2} \times 48 \ (37 \times 122)$

Exhibited Halifax, Nova Scotia, etc., 1972–3 (No. 27)

The Beaverbrook Art Gallery, Fredericton, N.B.

The vast charcoal cartoon for this subject, commissioned for Canada by Lord Beaverbrook, was carried out in 1918, preceded by innumerable sketches of soldiers in ink, chalk and pencil now scattered throughout various public collections in the Dominion. It worked out at twelve by forty feet, of which the little oil here is an exact miniature version. Knewstub tried to tempt Quinn into buying the huge cartoon but the American collector having lost his first enthusiasm for the works of John, and now beginning to find the eighteen-foot long 'Mumpers' a sufficient embarrassment, cabled back: 'Not interested. Entirely too large'. Lord Beaverbrook, on the other hand, believed a full-scale painting was still owing to him. This John never produced, counterarguing that Beaverbrook had no gallery as yet in which to display it. The charcoal cartoon was acquired for 550 gns at the first studio sale in 1962 by a collector from Chile. A further full-scale oil version, unfinished, also exists in a private collection in London.

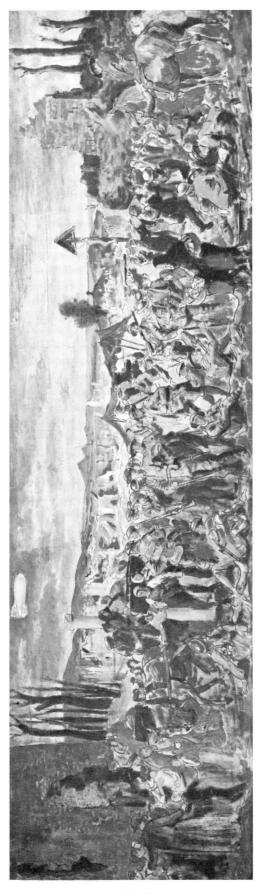

[165]

61 RONALD FIRBANK, c. 1917–1919

Pen and pencil (?) on paper

Signed 'John' bottom left

Present owner untraced

John's word for Arthur Annesley Ronald Firbank (1886–1926), witty author of Caprice, is 'evasive'; and, indeed, Firbank makes but one fleeting appearance in *Chiaroscuro*, where he is recalled 'struggling almost manfully with his asparagus and a bottle of wine' at the Eiffel Tower restaurant in Percy Street. In fact, John had parted with his sharpest observations of Firbank in a contribution to Kyrle Fletcher's Memoir of the writer, published back in 1930. This very short piece (two and a half pages) displays John the literary stylist at his ambitious best. For Caprice (1917), in which one of the characters bears the name Judy Johncock, John contributed designs for the frontispiece and dust-jacket. 'I spent a day or two over them and the design which in the end I destroyed,' he wrote from Renvyle. 'The best things just happen by themselves!' Caprice, he wrote. 'has its charming light quality', but he preferred Vainglory (1915) as being 'perhaps more idyllic – like a Fête galante'. On the other hand, 'I can only suggest that some of the names of the people are not pretty'. John's favourite among Firbank's novels was Valmouth (1919) - 'perfectly wonderful. Better than all the others' – which had as its jacket and frontispiece a black-and-white study by him of a lady in eighteenthcentury dress. In the first edition of *The Flower beneath the Foot* (1923) Firbank included a portrait drawn spontaneously by John 'at 2 a.m. in the Café Royal'; while Concerning the Eccentricities of Cardinal Pirelli (1926) contains another drawing done in 1915 as its frontispiece. 'I wish I had kept some of the after-dinner sketches I made of R.F., John told Anthony Powell, 'they were much better than the more elaborate ones for which he used to squirm.'

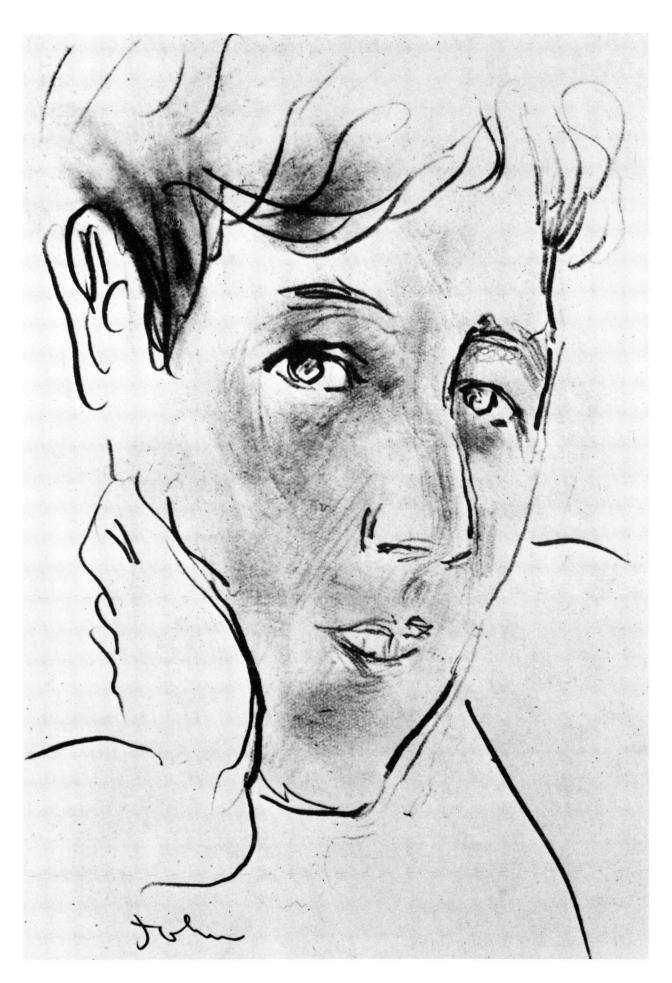

62 T. E. LAWRENCE, 1919

Pencil on paper, $14 \times 10 \ (35.5 \times 25.4)$

Collection: G. B. Shaw *The National Portrait Gallery*

Still in 'fancy-dress' as he described it, Lawrence was the most obviously paintable guest John encountered at the Hôtel Majestic, Paris, in 1919. There are several drawings which date from these first meetings, together with the oil painting shown at the Alpine Club Gallery which was bought by the Duke of Westminster for a thousand pounds and presented by him to the Tate Gallery. Later, John produced further portraits of Lawrence as Aircraftsman Shaw. Perhaps friendship is too strong a word to describe the relations existing between the two men. In *Chiaroscuro* are printed some fragments of letters from the sitter, recording his views on the exhibition of the Peace Conference portraits. 'I never saw eye to eye with him about pictures,' said John; though he seems to have been able to tolerate Lawrence's hardworked facetiousness and the naïve pleasure he took in being painted by every artist, good or bad. But Lawrence saw in John the perfect 'image-maker'. On the other hand, it is worth noting that John's portraits of Lawrence grow progressively more banal. Lawrence got on best, perhaps, with Dorelia. Like other neurotics, he derived comfort just from coming over and (having hidden his motor-cycle in case it 'offended') being near her. By the 1950s, John was speaking with some enthusiasm of Richard Aldington's biography of T.E.L.

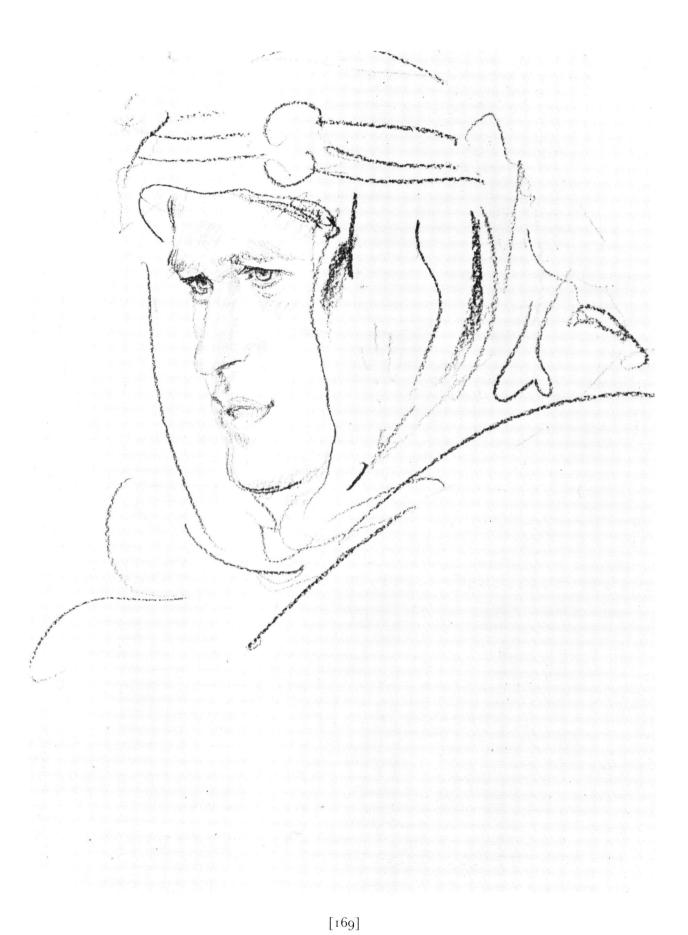

63 W. H. DAVIES, c. 1920

Oil on canvas, $29\frac{1}{2} \times 24\frac{1}{2} \ (75 \times 62)$

Exhibited Arts Council, 1948 (No. 33); R.A., 1954 (No. 349); Sheffield, 1956 (No. 25)

Collection: Miss Gwendoline E. Davies
The National Museum of Wales

John did not meet Davies (1871–1940) until long after the latter's book of verse, A Soul's Destroyer, and The Autobiography of a Super-tramp had made him famous. Davies' extolling of the simple life of the pedlar who is also a nature-lover precedes by only a year or two John's own caravanning days. The success of their ultimate meeting, and of the portrait which followed almost at once, was perhaps assured by their common cult of the open road. In Chiaroscuro, the artist assumed that the enraptured pose adopted by Davies, 'his hands clasped before him, his eyes focused, as it were, on Paradise, and his ears, it might be, intent on the song of an invisible bird', was perfectly natural to the sitter. Davies himself (in his own *Later Days*) explains it otherwise. Having wanted to sit quite still and not change his position, he concentrated his gaze on a 'little eye of light' in the curtain. After a while the round chink seemed to grow nearer and bigger. The trance was broken at length by the sound of John knocking the ashes out of his pipe: 'That I had almost hypnotized myself by looking so intently at that light is most certain.' Davies was a strict teetotaller and took it as a great compliment that John drank nothing during the six hard days' work he spent on the portrait.

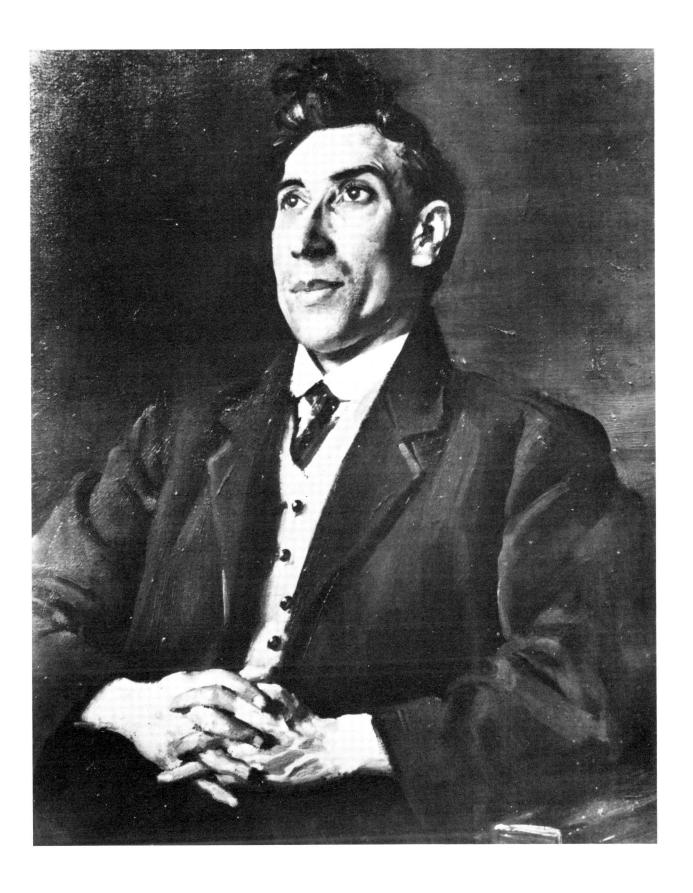

64 IN MEMORIAM AMEDEO MODIGLIANI, c. 1920

Oil on canvas, $50 \times 40 \ (127 \times 101 \cdot 5)$

Signed 'John' bottom right corner

Exhibited Temple Newsam, 1946 (No. 61); R.A., 1954 (No. 407)

The Executors of A. C. J. Wall

For John the primitive always exerted a strong fascination, whether the products of a genuine native culture, or their echoes in the work of Picasso and, somewhat later, in the sculptures of Modigliani. The stone head shown here was one of two which had struck his fancy in Modigliani's Montmartre studio during the summer of 1913. 'The floor was covered with them,' John recalled in *Chiaroscuro*, 'all much alike and prodigiously long and narrow.' It is not clear what the book is in this votive still-life, but it ought to have been Modi's 'bible', *Les Chants de Maldoror*.* To our regret, the Executors of the late Mr Wall's estate were not willing to give permission to re-photograph the picture. Its importance in the history of John's life and work has therefore obliged us to print from a reproduction approved by A. C. J. Wall during his lifetime.

^{*}Since writing this, we have been able to consult a letter from John to D. S. MacColl, dated 27th December 1944, in which the symbolism is explained, as follows: 'The book represents his [Modigliani's] Bible – Les Chants de Maldoror; the cactus, Les Fleurs du Mal; the guitar, the deep chords he sometimes struck; the fallen tapestry, the ruins of time.'

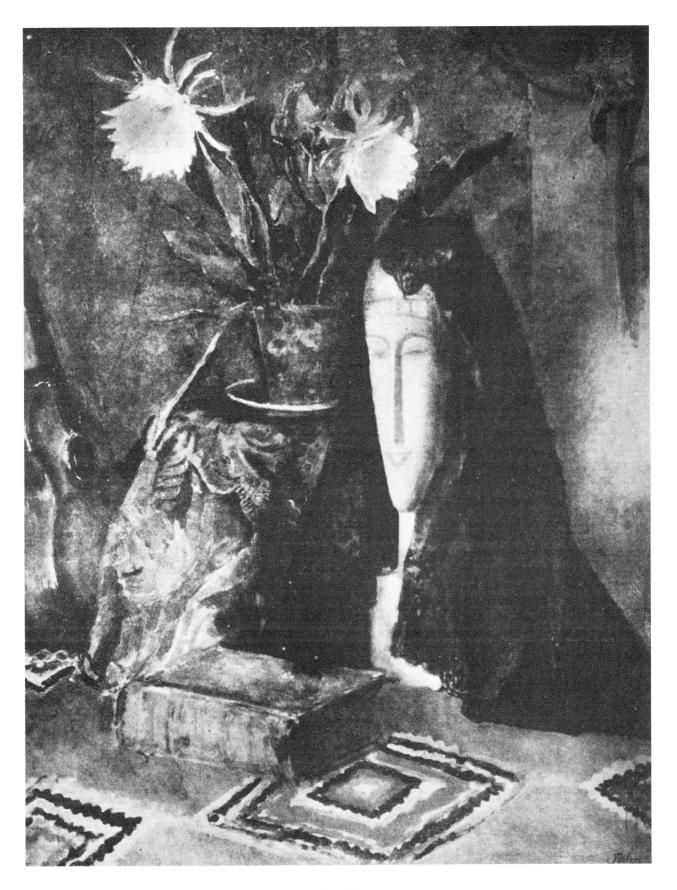

[173]

65 THE SPANISH GITANA, before 1921

Oil on canvas, $16 \times 13 \ (40.5 \times 33)$

Signed 'John' top right corner

Exhibited R.A., 1954 (No. 431)

Collection: Mrs Valentine Fleming

Miss Amaryllis Fleming

The painting was presented to Mrs Fleming by the artist in 1921: we have no clue otherwise as to the date of execution. It might be connected with one of the visits to Spain, if he had arrived there in time. But although he actually set out for Spain early in 1908, he did not arrive until May 1922, using it only once more as a convalescent post in the winter of 1954–5. If Mrs Valentine Fleming was right about her date, then John must have met this charming Spanish Gypsy through Fabian de Castro or in some band travelling in France.

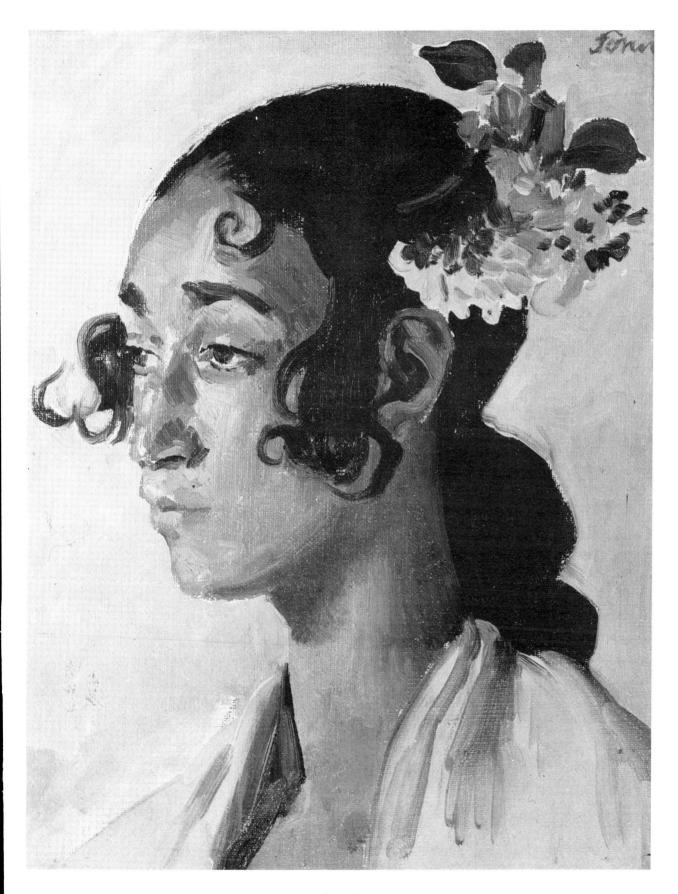

[175]

66 THOMAS HARDY, 1923

Oil on canvas, $24 \times 20 (61.5 \times 51)$

Signed and dated 'John 1923' top right corner

The Fitzwilliam Museum, Cambridge

The Hardy portrait is a notable expression of John's new-found respectability in the 1920s. In 1921 he had been elected A.R.A. and in the following year five pictures of his had been hung, including the most generally admired painting of G.B.S., already presented to the Fitzwilliam Museum. Hardy's likeness would soon follow Shaw's to that august collection. John met Hardy at Kingston Maurward on 21st September 1923, and, after several visits to Max Gate, completed the portrait by the middle of the following month. 'An atmosphere of great sympathy and almost complete understanding at once established itself between us,' John records in *Horizon* (December 1942). '... I wonder which of the two of us was the more naïve.' When he saw the finished portrait, Hardy remarked: 'I don't know whether that is how I look or not, but that is how I *feel*.' According to Florence Hardy, he also said he would rather have had this portrait bought for the Fitzwilliam 'than receive the Nobel Prize – and he meant it'.

An amusing footnote to the serious occasion was John's reappearance, partly as Meredith, in a mysterious dream where Hardy found himself carrying a heavy child up a ladder to safety, while the Meredith–John chimera looked on unconcernedly. If any meaning can be read into this, it may be that Hardy had always wanted (and been denied) children, while John's prowess in this sphere had rendered him an object of unconscious envy to his sitter. It is hard to see how the author of *Modern Love* fits into the dream-analyst's scheme of things (*The Times Literary Supplement*, 16th June 1972).

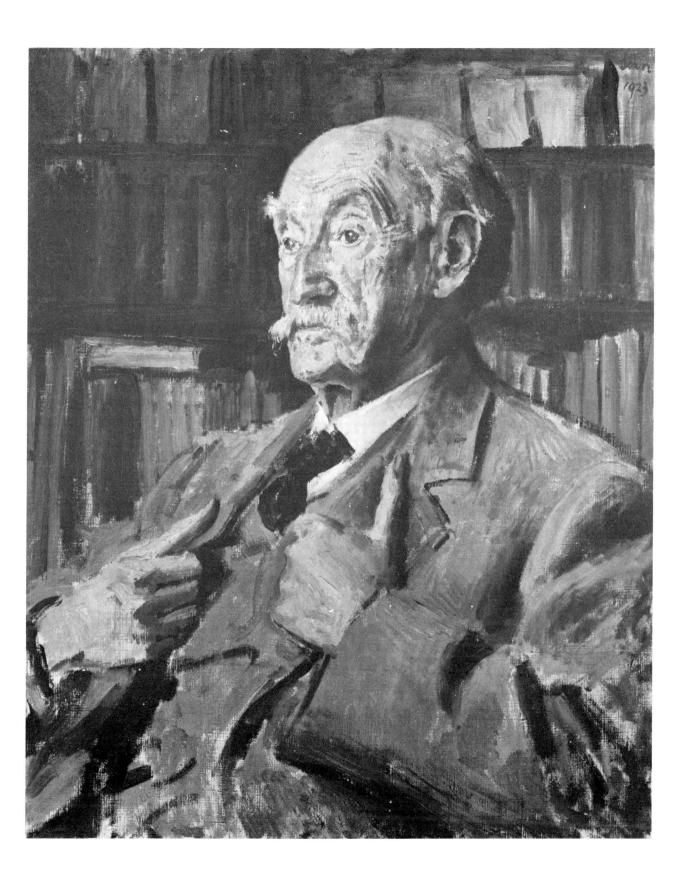

67a VISCOUNT D'ABERNON, 1927–31

Oil on canvas, $90\frac{3}{4} \times 60\frac{1}{2} (230.5 \times 156)$

Signed 'John 1932' bottom right corner

Exhibited R.A., summer 1931 (No. 318); Pittsburgh, 1933 (No. 143); Temple Newsam, 1946 (No. 54)

Collection: Lord D'Abernon; Helen Lady D'Abernon The Tate Gallery

John paid a visit to Berlin during March and April 1925, one result of which was his portrait of Gustav Stresemann, who was to share the Nobel Peace Prize with Briand in the following year, another this full-length picture of the British Ambassador, Lord D'Abernon. John moved, in fact, in 'diplomatic circles', and had his own key to a side entrance of our Embassy. Rare privileges, however, interspersed with rare adventures, failed to inspire the artist. The Stresemann portrait (now in Buffalo) just passes, but that of Lord D'Abernon comes as a severe shock to the admirer of John's best work. In a fever of mingled Angst and impatience, it might seem, he had risked a hit or the wildest miss. In fact, no actual painting was done in Berlin, where he merely met D'Abernon. Work did not begin till two years later. And then it proved unremitting, uninspired labour all the way. In 1933 Homer Saint-Gaudens, of the Carnegie Institute, Pittsburgh (somewhat overwhelmed, it is true, to be in correspondence with so noble a sitter), referred to the canvas as the *height* of John's effort, 'and there is no man on either side of the Atlantic who is regarded in such high esteem as the painter'. But by then both John and D'Abernon himself knew that the formal character demanded of such a picture had never really been in the artist's line. In December 1927, thanking D'Abernon for a sweetener of £,500, John admitted that much had still to be done. He would have to wait for the dark days to pass, however: there had been the harrowing experience of trying to complete Governor Fuller's portrait by artificial light. 'I feel your portrait,' he told Lord D'Abernon, 'is too fine a scheme to take any such risks with and I shall return to it later with the greatest enthusiasm.' Such words must have sounded ominous in the sitter's ear, for an integral part of the agony of being painted by John was the struggle to make off with one's rightful property before the disastrous process known as 'improving' began. But a more cheerful note was sounded in 1929, when Lady D'Abernon learned from her husband that John had made the face 'less bibulous'. Seen from five yards off it had become a 'fine costume picture'. As late as July 1931, John proposed or accepted fresh revisions. But now a second (prospective) buyer seemed to materialise in the shape of Lord Duveen, and the Academy's Secretary was putting out feelers about a Chantrey purchase. That Lord D'Abernon already toyed with the idea of selling his scarcely-acquired likeness suggests dissatisfaction. But for reasons which don't concern us, no sale took place, and John received his full £2,000 from the Ambassador. The work was finally presented to the Tate by Helen Lady D'Abernon in 1950.

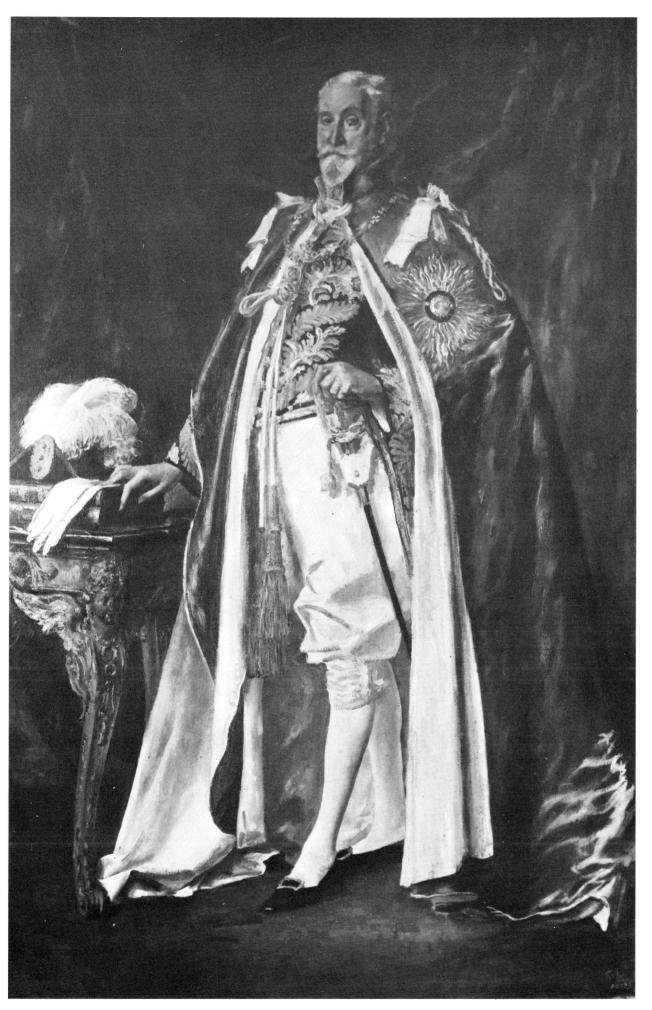

[179]

67b VISCOUNT D'ABERNON

Photograph of the subject of the previous painting in his Garter robes

The John Estate

This is a somewhat disquieting photograph, though its practical purpose was the innocent one of fixing in the artist's mind the correct disposition of the robes. Not only is there a discrepancy in the likeness: this discrepancy (the result of many weary alterations) over-advantages the portly little man who posed. John commonly elongated the sitter's head, but the amount of painter's surgery that has gone on here seems for once unacceptable. Lord D'Abernon has also gained twelve inches in height. The splendid double-flexed curve of the pictured figure has been conjured out of thin air or from the guardsman who stood for the costume. No wonder Helen D'Abernon wrote on the back of a print of this photograph: 'It shows how unlike [my husband] the "parade" portrait was and is.'

[181]

69 THE LITTLE RAILWAY, MARTIGUES, 1928

Oil on canvas, $18\frac{1}{2} \times 21\frac{1}{2} (47 \times 54 \cdot 5)$

Signed 'John' bottom left

Exhibited Temple Newsam, 1946 (No. 48)

The Tate Gallery

John's connection with Martigues, which he had discovered with so much excitement in 1910, came to an end in 1928 when the Villa Ste Anne was sold. The 'little railway' in question was that on which one embarked at Pas des Lanciers, a station on the line from Marseille. Over the years, in John's estimation, Martigues had changed for the worse. It was no longer the simple fisherfolk's community, visited by an occasional artist or such old friends as Roy Campbell, T. W. Earp and Horace de Vere Cole, but, largely because of the new causeway running along the north shore of the Etang de Berre, had become part of the ugly modern world.

70 JAMES JOYCE, 1930

Chalk on paper

Inscribed, signed and dated 'James Joyce Augustus John Paris 1930' lower right

Present owner untraced

John visited the writer in November 1930. A photograph published in Chiaroscuro shows them arm-in-arm, John himself appearing the more anxious of the two to take part in this display of solidarity. Indeed, he complains of the special efforts he had to make to jerk Joyce out of his bourgeois reserve. A number of drawings were made, in which the sitter took a great interest. 'He explained,' says John, 'that the poverty of his beard was due to an early accident to his chin, but I did not feel empowered to restore the missing growth.' In the drawing shown here, however, he has been a hair or two more generous than the camera. The plan was for this drawing to serve as frontispiece to *The Joyce Book*, a volume of Joyce's poems with musical settings by different composers, edited by Herbert Hughes (Sylvan. Press and O.U.P., 1933). On 30th October 1930, Joyce wrote to Mrs Herbert Gorman: 'A. J. started my portrait a few days ago with that highly treasonable Stuart royal tie.' But afterwards Joyce was dissatisfied with John's drawings, claiming that they failed to represent accurately the lower part of his face.

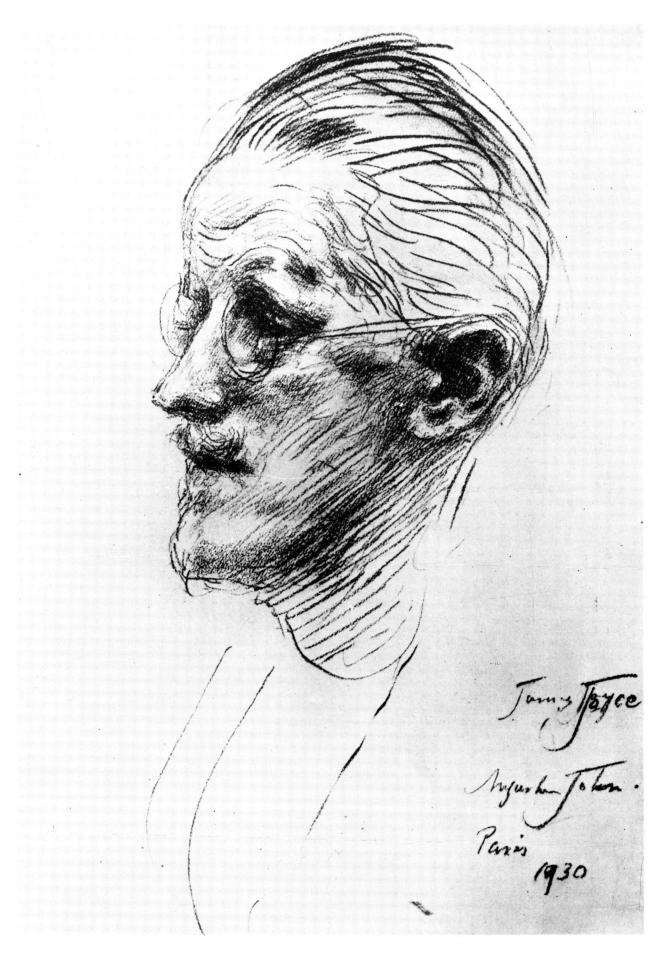

72 JOSEPH HONE, 1932

Oil on canvas, $20 \times 15\frac{3}{4}$ (51 × 40)

Signed 'John' bottom left

Exhibited 'Contemporary Welsh Art', National Museum of Wales, 1935 (No. 34); Arts Council, 1945–6 (No. 90)

Collections: J. E. Fattorini, Flight-Lieutenant Adams *The Tate Gallery*

In April 1957, Joseph Hone (1882–1959), best known for his biography of Yeats, wrote to the Tate Gallery, of this portrait: 'I stayed at Fryern [Court] in the earlier part of the summer of 1932, and it was there that John painted the Tate portrait of me. I have found a letter of his dated August 1932 in which he says, "I would like to do another drawing or two when you return in October, as there is an aspect of you I didn't hit off." I wasn't able to return in October; perhaps it was as well as far as the portrait is concerned – I remember Mrs John [Dorelia] had with difficulty persuaded him not to work on it further.' R. S. Thomas, distinguished poet and Vicar of Eglwysfach, has published some verses in *The Stones of the Field* (1946) which convey the powerful, if unexpected, impression made upon him by this portrait.

	60	H. S. Goodhart-Rendell, F.R.I.B.A.		1065	Portrait of a Woman (red chalk)
	94	The Rt Hon Vincent Massey		1066	Walter de la Mare (chalk)
	183	Mrs Oliver Harvey			
	230	The Lord Alington	1951	129	Caspar John
				132	Mrs Robert Adeane
1941		W. B. Yeats (Chantrey Purchase)		135	Young Negress
	164	Major-General The Earl of		779	Reclining Nude
		Athlone, K.G.		879	Two Heads of Women (chalk)
10.40	100			880	Sketch for Composition (pen and
1942		The Mask (Harry Melville)			wash)
	110	The Viscount Caldecote, C.B.E.			
1049	020	A :- CL :- CM	1952	1114	The Hurdy-Gurdy Man (red chalk)
1943	238	Air Chief Marshal Sir Charles F. A.			An Apostle (red chalk)
		Portal	W 100 UN 000		
1944	5.1	Dr H. H. E. Craster, Bodley's	1953		Dr Hubert Noel (chalk)
1311	31	Librarian		984	The Disciple (chalk)
	220	General Sir Bernard Montgomery			
		Lawrence J. Clements, Esq (chalk)	1955	98	Gloxinia (Chantrey Purchase)
		Poppet (chalk)			
		Lauretta [Nicholson] (chalk)	1957	89	Edward Grove (Chantrey Purchase)
		Mary (chalk)	1050	7.4	Til I D (CI
	997	General Sir Bernard Montgomery	1958	/4	Theodore Powys (Chantrey
		(chalk)			Purchase)
			1050	99	Danalia
1945		Mrs Michael Pugh (chalk)	1959		Dorelia Simone
		General Sir Hastings Ismay (chalk)		91	Simone
		The Duke of Alba (chalk)	1960	59	Portrait of a Man
		Master Tom Pugh (chalk)	1900		The Late Viscount D'Abernon
		Master Tim Pugh (chalk)		100	The Late Viscount D Abernon
		The Duchess of Montoro (chalk)	1061	Died	31st October
	1123	Michael Pugh, Esq (chalk)	1301	Died	31st October
1950	3	Matthew Smith (Chantrey	1962	193	Dorelia
1330	5	Purchase)	1304		The Blue Lake
	58	The White Feather Boa			Portrait of the Artist
		Henry Elphin John			Lady with a Scarf
		Gonnoske Komai			Family Group
		The Little Concert			Ursula Tyrwhitt
					,

List of Owners

Sir Robert Adeane: 22

Messrs Thomas Agnew and Sons: 32

Boston, Print Department, Public Library: 40

Mr Richard Burrows: 23

Cambridge, Fitzwilliam Museum: 37, 41, 45, 48, 56, 66

Mr Cass Canfield: 71

Cardiff, National Museum of Wales: 3, 29, 63, 73

Mrs Thelma Cazalet-Keir: 21, 44, 54

Messrs P. and D. Colnaghi: 27 Mr William A. Coolidge, 79

Detroit, Institute of Arts: 55

Mr Richard Driver: 34

Dublin, National Gallery of Ireland: 52

Miss Amaryllis Fleming: ii, v, 65, 81

Mr Brinsley Ford: 46, 76

Fredericton, N.B., Beaverbrook Art Gallery: 60

Mr and Mrs John Gardner: 2

Mr Peter Harris: 11, 15, 35, 50

Mrs R. M. Hughes: 75

John Estate: i, iii, iv, vi, vii, viii, 39, 67b

Lady Kleinwort: 14

Liverpool, Walker Art Gallery: 74

London, Imperial War Museum: 59

London, National Portrait Gallery: 62

 $London, Tate\ Gallery: 1, 9, 13, 16, 20, 43, 57, 67a, 69, 72, 77$

London, Slade School of Fine Art, University College: 28

Manchester, City Art Gallery: 4, 5, 8, 30

Melbourne, National Gallery of Victoria: 49, 68

Gwen Lady Melchett: 17, 25

Miss Jemima Pitman: Frontispiece

Private Collections: 6, 10, 12, 24, 26, 33, 38, 51, 53, 78

Mr Peter A. Salm: 58

Mr and Mrs Benjamin Sonnenberg: 47

Mr Anthony Speelman: 36

Toronto, Art Gallery of Ontario: 18

Mr and Mrs Stephen Tumim: 7

Mrs Julian Vinogradoff: 19

A. C. J. Wall Estate: 64

Sir Charles Wheeler: 82